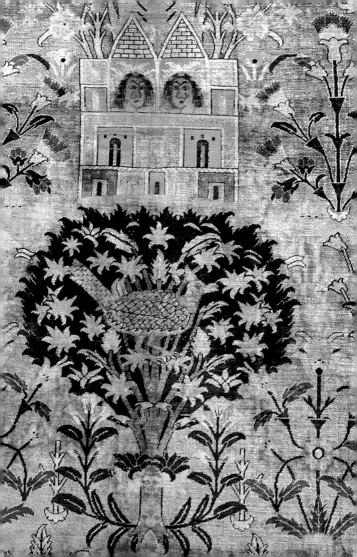

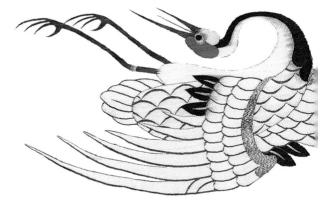

BIRDS

of a feather…

ST PETERSBURG • 2019

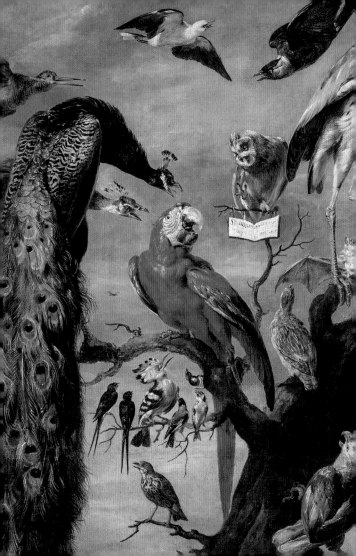

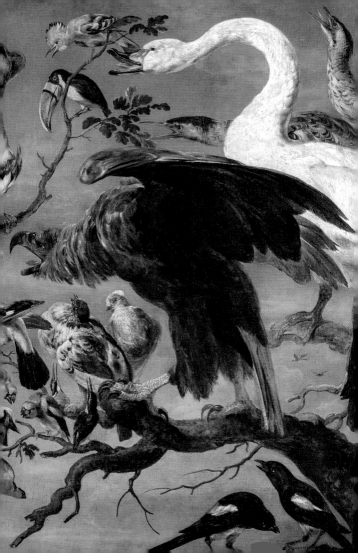

THERE ARE SOME TEN THOUSAND SPECIES OF BIRDS ON THE EARTH. THEY COME IN ALL THE COLOURS OF THE RAINBOW, IN ALL SHAPES AND SIZES, AND IT WOULD BE IMPOSSIBLE TO SUMMARISE BRIEFLY THE MANY ROLES PLAYED BY SUCH A VARIETY OF DIFFERENT BIRDS IN THE HISTORY OF MANKIND. THEY HAVE REPRESENTED SUN AND PEACE, DARK AND WAR; THEY HAVE PROVIDED FOOD IN THE FORM OF MEAT AND EGGS, CLOTHING AND ADORNMENT IN THE FORM OF FEATHERS; THEY HAVE BEEN COMPANIONS AND PETS. BUT MOST OF ALL, THEIR APPARENTLY EFFORTLESS SOARING THROUGH THE SKY HAS INSPIRED POETS AND ARTISTS TO SEE IN THEM THE EMBODIMENT OF THE SOUL, THE FLIGHT OF INSPIRATION. MOST BIRDS CAN FLY, ONLY ABOUT FORTY OF THOSE TEN THOUSAND SPECIES BEING TOTALLY DEPRIVED OF FLIGHT (INCLUDING OSTRICHES, PENGUINS AND KIWIS), AND MANKIND DREAMED FOR CENTURIES OF IMITATING THEM BEFORE FINALLY DISCOVERING THE POWER OF FLIGHT (LEONARDO DA VINCI'S DRAWINGS OF FLYING MACHINES DATE FROM ABOUT 1505).

But the mysteries of birds are many. If most have a recognisable call, a lot of them can sing. Even apparently simple songs are made up of multiple notes: the song of the wren, for instance, if slowed down is revealed to consist of 740 notes per minute! This is made possible by the nature of their vocal organ, a syrinx (rather than the mammal's larynx), which allows them to produce more than one note at a time. And since the bones of birds are light and hollow, they were used to make some of the earliest musical instruments: a five-hole flute found at Ulm in Germany is thought to be about 35,000 years old. While most have little or no sense of smell, unlike humans they can see ultraviolet light, which means that they see in four dimensions – they are tetrachromatic.

While a large group of any birds is known as a flock, as you will see, in common parlance the flocks of many birds have popular names that reflect their nature and how they are perceived.

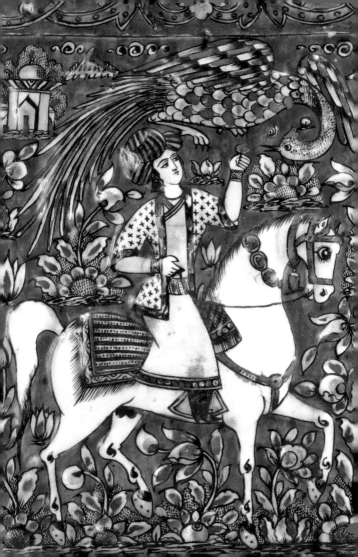

Mythological birds

Many mythological creatures in different world cultures are birds. Some combine elements of other beasts (or humans) with wings or feathers, claws or beaks. Here are some of the most remarkable.

ALKONOST
GAMAYUN
HARPY
GARUDA
THUNDERBIRD
FIREBIRD
ROC
SIMURGH
SIREN
SIRIN
STYMPHALIAN BIRDS
PHOENIX
FENGHUANG

Rider with
a Magic Bird
Persian tile
19th century

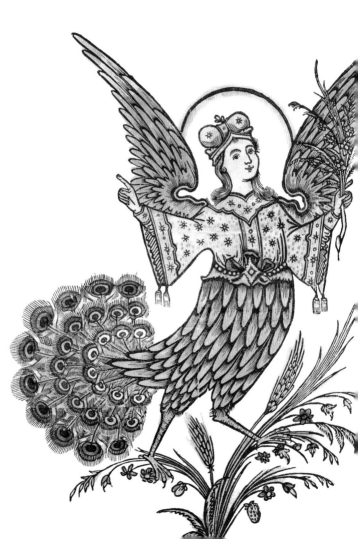

ALKONOST 🐦 With her roots deep in medieval Slavic literature, the Alkonost is a beautiful female creature with the lower body and wings of a bird but the arms, shoulders and head of a woman. Frequently mentioned in Russian religious verse and in popular prints, she is remarkable for her glorious singing voice that charms all who hear. One folk print, for instance, bears the text:

Alkonost near paradise does live…
And when she lets her melody ring forth
She loses all awareness of herself,
And those who then do hear her voice
Forget all else and to oblivion succumb:
Then the mind doth fade and the spirit leaveth the body.
Her songs console the saints and proclaim their future joy.

A prophetic bird, the Alkonost is also a bird of sorrow, perhaps because of her origins in the Ancient Greek legend of Alcyone. When Alcyone lost her beloved husband Ceyx, who disappeared in a storm at sea, she wept and wept and then threw herself into the waves. Out of pity the gods turned her into the bird we know today as the kingfisher or 'halcyon bird', who darts to and fro across the waters in a flash of startling blue. According to some versions of the legend, Ceyx too was turned into a bird.

Alkonost
Russian print
19th century

11

Headlong from hence to plunge herself she springs,
But shoots along, supported on her wings;
A bird new-made, about the banks she plies…
Now lighting where the bloodless body lies,
She with a fun'ral note renews her cries…
Then flickering to his pallid lips, she strove
To print a kiss, the last essay of love.
Whether the vital touch revived the dead,
Or that the moving waters raised his head
To meet the kiss, the vulgar doubt alone;
For sure a present miracle was shown.
The Gods their shapes to winter-birds translate…

Ovid, from *Metamorphoses*. 1st century BCE
Tr. Samuel Garth and John Dryden (17th century)

Like other Ancient Greek subjects the tale was taken
up by other cultures. In Russia, for instance, the story
features in a number of ancient texts of Byzantine
origin. The bird's Greek name ἀλκυών (halcyon)
was transformed into the mysterious Alkonost.
The Alkonost is often shown in company with
another prophetic and heavenly bird, the Sirin, who
has wings but lacks arms.

Kingfisher. Flemish tapestry. 16th century

GAMAYUN 🐦 According to ancient legends
of the Eastern Slavic lands Gamayun (sometimes
spelled Hamayun) was born along with the world
itself. She has seen everything, knows everything, can
see everything that is to come. When Russian artist
Viktor Vasnetsov produced the most famous image
of her in 1898, it inspired the eighteen-year-old poet
Alexander Blok to write his own word-picture
of the mystical bird-maiden.

Across the waters smooth, unending,
by sunset purple-robed, she sings
and prophecies, alone and bending,
too weak to raise her ruffled wings;
Foretells the Tartars' bondage dire,
foretells the torturer's bloody trail,
hunger and turbulence and fire;
evil grows strong, and just men fail.
Full of foreboding and of fear
her proud face burns with love, but, still
proclaiming that these things draw near,
with clotted blood is red her bill.

Alexander Blok,
from *Hamayun, the Prophetic Bird.* 1899
Tr. A. L. Basham

Gamayun
Viktor Vasnetsov
Russian. 1898

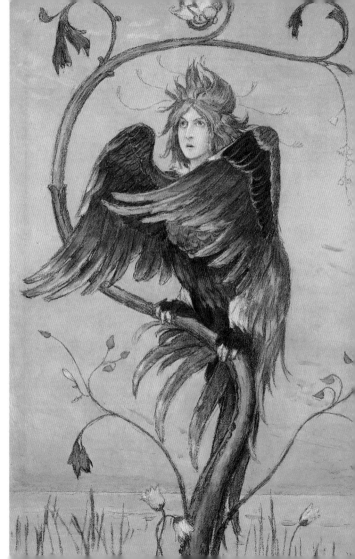

Folk tales known as 'The Songs of Gamayun' tell
of the creation of the world and days long past, of
the origins of pagan gods and of Slavic myths, and
praise the gods and all their deeds. Although the
bird can tell the future, not everyone can hear her
mysterious voice and understand her message.

This very Russian mythical bird grew not out of Greek
mythology but out of ancient Persia (Iran), where
Humayun is still a popular name. There, the Huma
bird is a heavenly creature, a bird of paradise,
prosperity, happiness, success. Never alighting upon
the earth, the Huma bird combines male and female.
In Persian literature the bird feeds on bones but
is always a good omen and a sign of royalty, an
association that recurred in Mughal India, where the
feathers in a ruler's headwear were said to be those
of the Huma bird. In Sufism, simply to catch a glimpse
of the bird's shadow is a guarantee of happiness.
But in Russia, the associations are very different.

The word *gamayun* became a noun and a verb in the
local dialect in some provinces of the vast Russian
lands: in central Russia, for instance, it meant to
speak loudly or shout and be rowdy, but further east,
in the Central Urals, it meant to work hard. There
was even an ethnic group in the Urals known as
the gamayuns, identified by their drawling speech
and unusual sense of humour.

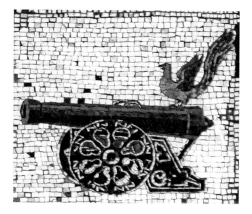

*Arms
of Smolensk
Russian mosaic
Late 19th century*

For seven centuries Gamayun has been part of the arms of the ancient Russian city of Smolensk, which were approved by Prince Gleb Svyatoslavich in 1393: 'Against a silver field a black cannon on a gold gun carriage, and on the barrel sits a heavenly bird.' That was how the arms appeared in the Book of Titles of Russian Tsar Alexey Mikhaylovich in 1672. A large cannon in the Arsenal of the Kremlin in Moscow is known as Gamayun. Weighing 102 poods (about 1,671 kg or 3,684 lb), it was cast in 1670 by Martyan Osipov. Just why it was called Gamayun is unclear, but it was perhaps a call to the bird of joy to bring victory over all enemies.

17

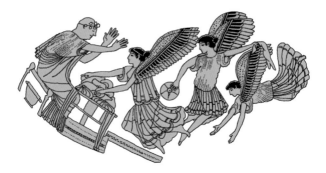

HARPY 🐦 Birds of prey who steal children and human souls, in Greek and Roman mythology harpies were ugly creatures, half-bird, half-woman, with wings and long claws, often with a long beak projecting from their human faces. Various harpies are named in ancient Greek and Roman sources: Aello (Whirlwind), Ocypete (Rapid), Aellopus (Whirlwind-like), Podarge (Fleet-footed) and Celaeno (Gloomy). The gods sent the harpies down to punish mortals, depriving the victim of all peace, by night and by day. Appearing and disappearing in a whirlwind, they screeched and flapped their wings, got in the way and contaminated food. In modern English, the word 'harpy' is often used to describe a nagging or screeching woman.

Harpies Stealing Food Drawing after a red-figure vase Ancient Greek c. 480 BCE

GARUDA 🐦 With his mixture of human body and bird's wings (and sometimes a beak in place of nose and mouth), the huge Garuda comes from ancient Hindu mythology but also appears in Buddhism and Jainism. Barely had he hatched from an egg than Garuda shot up into the heavens and the gods were so blinded by the rays of light emitted by his feathers that they took him for Agni the fire god. Garuda was thought to be the ancestor and ruler of all birds, but he also served as the vehicle bird of the god Vishnu, one of the three main Hindu deities

Garuda
Indian relief
Late 2nd century

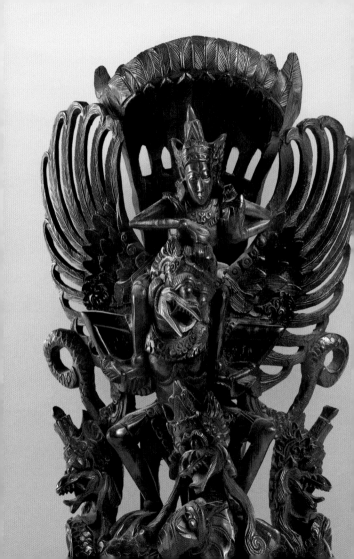

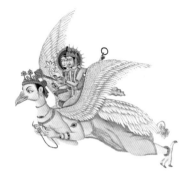

who created the universe. Riding atop Garuda,
Vishnu travelled his lands and even descended into
the underworld in order to do battle with the Nagas
(snakes with human heads). This idea of the conflict
between birds and snakes (symbolising the world
of light and the chthonic world or underworld) is
part not only of Hindu belief but of mythology
across the world. Garuda is the uncompromising
enemy and destroyer of snakes and even his name
can be translated as 'devourer'.

So central is this function of protective watchfulness
that Garuda is an important element of the state
insignia of a number of Asian countries, notably
Indonesia and India. Garuda is also the name of
the national airline of Indonesia.

THUNDERBIRD 🖋 The indigenous peoples
of North and Central America tell tales of the gigantic
Thunderbird who is responsible for whipping up
storms. According to the Quileute people of what is
now western Washington State: 'The Thunderbird's
feathers are as long as the paddles of a canoe. When
he beats his wings the wind blows strongly and
thunder claps. And lightning flashes when he opens
and closes his eyes. He lives in a dark cave in
the mountains and eats whales.'

Long ago, or so it is said, there was a terrible famine
in the land of the Quileute and the chief called on
the tribe's Great Spirit, the Thunderbird. When
the vast bird appeared in the sky: 'His wings from tip
to tip were twice as broad as two dugout canoes and
his eyes flickered with fire. The Thunderbird gently let
a whale down onto the earth and then soared up into
the sky, disappearing thence from whence he came.'

According to the Ojibwe or Chippewa people of
Canada and the northern United States of America,
rolls of thunder are made when thunderbirds fight
and argue. In the winter they fly south, along with
storms and hurricanes, returning in the spring like
ordinary birds, 'building huge nests of clouds and
laying eggs that are white as snow with golden flecks
on a bed of their own sparkling feathers'. When their
chicks are born and their feathers have developed,

the little ones play amidst the clouds, pulling at each other's tail feathers and spending whole days playing the traditional North American game of lacrosse. Once upon a time, says the legend, a thunderbird chick threw the ball so hard that none could catch it. Falling over the side of the cloud and down to the land, it landed with a thump so hard that it knocked a huge uneven dent which became the Hudson Bay.

The Thunderbird is known to different tribes by different names: to the Cherokee of the Southeastern Woodlands he is Tlanuwa; for the Sioux he is Wakinyan, while the Kwakiutl of the Pacific Northwest Coast of North America call the Thunderbird Tsoona.

Thunderbird on a Whale with a Wolf and a Snake (symbol of lightning) After a painted panel of the Nuu-chah-nulth people of Canada. 1850s

23

FIREBIRD With its feathers flickering like fire, this bird appears only in secret at night, and can never be caught. It is in pursuit of the Firebird that the hero of Russian fairytales sets off on his adventures, ignoring warnings that the Firebird can bring disaster as well as good fortune. First he finds a shining feather…

It lay in the path, glittering like a flame; for the sun was on it, and it was a feather of pure gold… The horse of power spoke and said:
'Leave the golden feather where it lies. If you take it you will be sorry for it, and know the meaning of fear.'
But the brave young archer sat on the horse of power and looked at the golden feather, and wondered whether to take it or not… And in the end… he leapt from the saddle, picked up the golden feather of the fire-bird, mounted his horse again, and galloped back through the green forest…

Arthur Ransome, from *Old Peter's Russian Tales*. 1916

Firebird. Russian embroidery. 19th century
Ivan Tsarevich and the Firebird. Ivan Bilibin. Russian. 1899
On pp. 26–27
Fabulous Bird. French embroidery. 1780s
Magic Bird. Spanish embroidery. 17th century

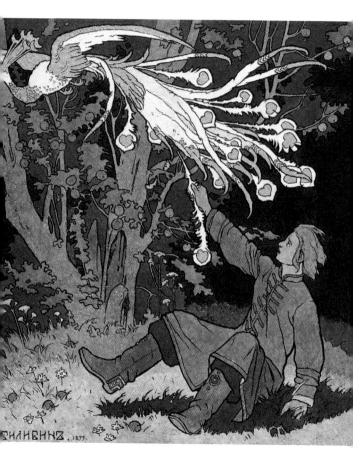

The Firebird and the hero Prince Ivan (Ivan Tsarevich), appear in different tales, but underpinning all of them is the idea that one must hope for happiness on earth, that happiness must be sought even at the risk of disaster. Thus the tale of the Firebird has a moral: that we should strive even for that which seems to be beyond our grasp.

In the first decades of the twentieth century the Firebird came to fame outside Russia, thanks in part to the ballet of that name set to music by Igor Stravinsky, with colourful costumes designed by Léon Bakst. First performed in 1910 by the Ballets Russes in Paris, where it was rapturously received, the ballet is still very much part of the repertoire across the world. With time, the Firebird came to symbolise the very essence of Russian culture.

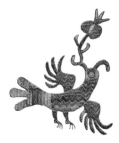

ROC 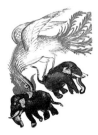 Legends abound in the Middle
East about the Roc, a vast bird of prey. Sinbad,
sailor hero of The Arabian Nights, lands on an
uninhabited island where he comes across
a strange white dome. Unable to get in he
decides to measure it by walking around it:
the circumference takes him full fifty steps!
At which point he recalls the tales brought back
by other explorers of a bird so huge that it feeds
its young on elephants… Sure enough, the 'white
dome' proves to be the egg of the Roc.

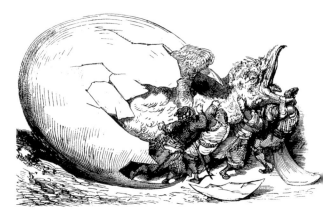

If Sinbad was a legendary hero, the very real thirteenth-century Florentine merchant and traveller Marco Polo also heard tales of the great bird during his visits to Persia, India and China and other lands previously unknown to Europeans. He was told that the wind caused by the Roc's wings could knock a man off his feet.

Another thirteenth-century figure, Kublai Khan, ruler of the Mongol Empire, sent brave young warriors out to catch the Roc. They went to the island of Madagascar but were unable to capture the bird, bringing back only a single feather that measured twelve paces, its quill as thick as two palm trunks.

SIMURGH In his epic the *Shahnameh or Book of Kings*, Abu 'l-Qasim Ferdowsi gave poetic form to many ancient Persian myths and legends, not least among them that of the Simurgh.

Roc
Persian miniature
18th century

The Merchants
Break Open
the Egg
Gustave Doré
French engraving
1865

Now there standeth far from the haunts of men
Mount Alberz, whose head toucheth the stars, and
never has mortal foot been planted upon its crest.
And upon it had the Simurgh, bird of marvel, builded
her nest. Of ebony and of sandalwood did she build it,
and twined it with aloes, so that it was like unto
a king's house.

This terrible bird found Zal, son of Saam, abandoned
at the foot of the mount and picked him up in her
claws to take him back to feed her young:

But when she had brought him her heart was stirred
within her for compassion. Therefore she bade her
young ones spare the babe and treat him like a brother.
Then she chose out tender flesh to feed her guest, and
tended the infant forsaken of his sire. And thus did
the Simurgh, nor ever wearied till that moons and
years had rolled above their heads, and the babe was
grown to be a youth full of strength and beauty.

Ferdowsi, from *Shahnameh*. Between c. 977 and 1010
Retold by Helen Zimmern (1886)

When the time came for Zal to leave the nest,
Simurgh sent him out into the world with a feather
and a promise that if he ever needed help he should
toss the feather into a fire.
In *The Wonders of Creation* the thirteenth-century
Persian philosopher Zakariya al-Qazwini described
the legendary Simurgh as the wisest and most
powerful of all birds, dispensing advice and warnings:
'The air was filled with all the colours of the rainbow,
the feathers and wings of the bird emitting beautiful
sounds, and it gave off a pleasant scent…'

Simurgh
Carrying off
a Young Man
Basāwan
Indian miniature
c. 1590

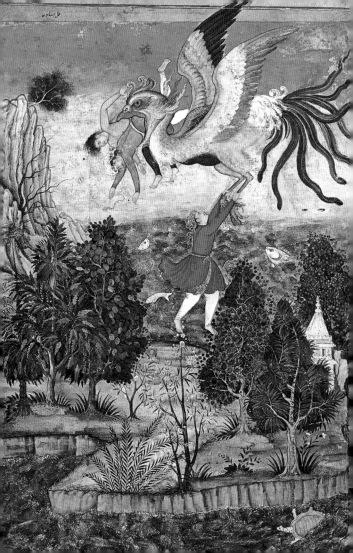

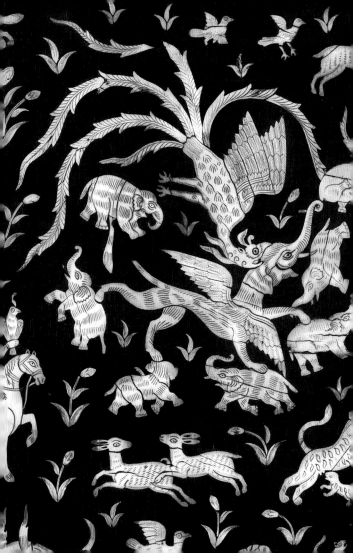

Outside Persia the legendary Simurgh also crops up in Sufic poetry and in the literature of other lands and cultures. Many peoples of India believed that the Simurgh would save them from dangerous dragons or could point out a true path to the lost. In Eastern lands the bird was seen as a fortune teller and so anyone wishing to know the outcome of an important event would lay their hand on a Simurgh's feather. Mythological birds and beasts often come together on works of art. On this fine cabinet made in India the craftsman has depicted real flowers and beings but also two fantastical figures. Easily recognisable from his traditional tail, the gigantic Simurgh can be seen attacking a beast with an elephant's head and the body of a winged lion. Also clearly vast in size, this beast grabs a little elephant with each paw, using his tusk and his trunk. Although it may not look like the legendary Roc, this is clearly a reference to that vast bird's habit of feeding its young on elephants. Yet there is no mention anywhere in Arabian legends of the Roc having a lion's body or an elephant's head or of it being attacked by the Simurgh.

Simurgh and Elephants. Indian cabinet
Late 17th – early 18th century

A similar subject, in which the Simurgh and a lion-headed beast do battle, appears on a felt carpet in the Hermitage Museum, discovered in one of the frozen barrows of Pazyryk (Ancient Altai, fourth century BCE).

Related to the Simurgh is the Persian Senmurv, a bird with a dog's head covered with fish scales that was in its element in the air, on land and in water. Amulets bearing images of the Senmurv – some of them two-and-a-half millennia old – circulated among the ancient Persians, the Scythians and the Permic and Ugric peoples. The Simurgh/Senmurv often appears on vessels, carpets and weapons. A seventh-century gilded dish shows the Senmurv in flight, holding the goddess of water and fertility Aredvi Sura Anahita, who holds out a bunch of grapes to him. According to ancient Persian legend this 'king of birds' lived on the 'Tree of all seeds' or 'World tree' and 'When the Senmurv… sits upon the tree he breaks a thousand branches and scatters seeds everywhere'. Anahita awaits this moment, since she is responsible for the vegetation of the world. The more seeds fall to the ground the more flowers and fruits there will be for her to water and nurture.

Senmurv. Sasanian dish. Early 7th century

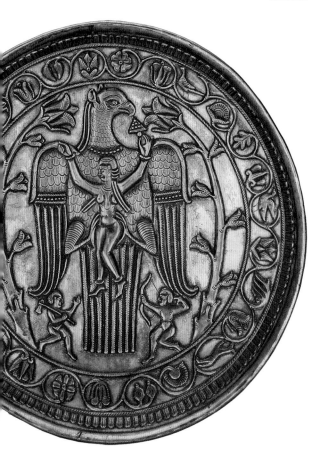

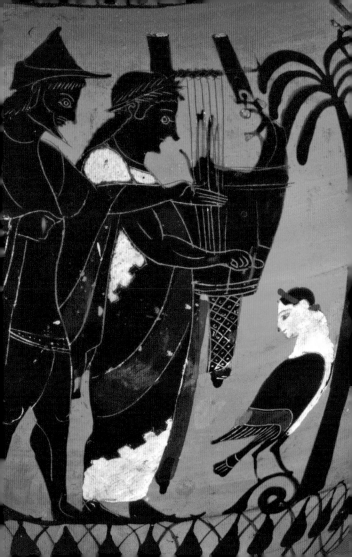

SIREN 🐦 Described in almost identical fashion in myths and legends in both East and West, sirens were birds with a female head, of great beauty and with a glorious voice which could so charm men that they lost their reason and all too often their lives. Odysseus, the Ancient Greek hero whose tale is told in Homer's *Odyssey* (eighth century BC), was not known as 'the Cunning' for nothing. When his ship had to sail past the island inhabited by the legendary sirens he had no wish to die and yet he wanted to hear their voices. He had his sailors stuff their own ears with wax and lash him to the mast, warning them not to come to his aid whatever he asked. Thus he heard the beauty of the sirens' song but he and his men sailed safely past the island and survived.

Apollo, Hermes and a Siren Ancient Greek black-figure vase 530s BCE

Siren Ancient Greek black-figure vase 560s BCE

SIRIN 🐦 Although very like the Alkonost in appearance, the legendary Sirin, half bird, half-maiden, has no arms, only wings. The two beautiful female birds are often depicted together in Russian folk art and the texts that describe them are often very similar, further proof of their close relationship.
The Sirin often appeared on Russian popular prints. One of these shows her with a peacock's tail, seated on a flower, and bears the accompanying text:

She sings sweetly;
And no man of this world can hear her song:
For when he hears it he forgets himself and dies.

Temple Pendant
with Sirin-birds
Russian
12th – early
13th century

Sirin-bird
Russian print
19th century

On pp. 40–41
The Garden
of Paradise
Russian print
First half of
the 19th century

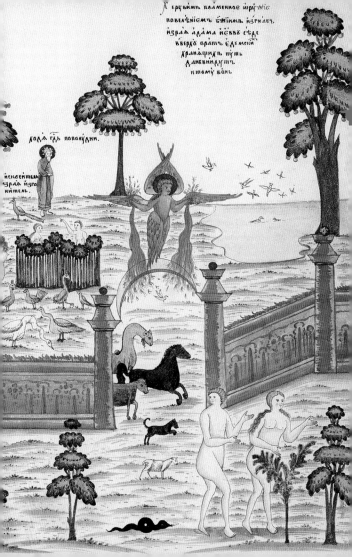

Херувимъ пламенное оружіе
повеленіемъ Божіимъ изрицаетъ.
Израиль Адама изъ нея седе
въ верху вратъ Еденскихъ
хранящихъ путь
да не внидутъ
къ тому в онь

колія где пополудни.

Исполнителя
Израиль изго
нителъ.

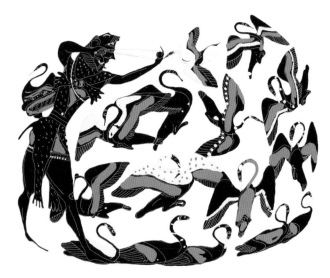

STYMPHALIAN BIRDS 🐦 These birds
of Ancient Greek mythology had copper (or bronze)
feathers, claws and beaks and were extremely aggressive.
Ready to eat everything that came their way, the birds
were not averse to a little human flesh, and their
feathers could be shot like arrows at their victims.
They took their name from the swamp or lake in
Stymphalus where they lived, keeping the nearby
populace in a state of perpetual fear.

*Heracles and
the Stymphalian
Birds
Drawing after
an Ancient Greek
black-figure vase
c. 540 BCE*

One of the tasks or labours set to the Ancient Greek hero Heracles (Roman Hercules) was to defeat the Stymphalian birds. He managed to shoot some of them with arrows tipped with poison taken from the Lernaean Hydra and, prompted by the goddess Athene, frightened the rest away with a terrible clashing of cymbals (the *krotala*).

Abandoning Arcadia, the birds settled on an island belonging to the Greek god of War, Ares, not far from the Pontos Euxeinos (now the Black Sea).

Pausanius, a Greek geographer writing in the second century, related:

In Stymphalus there is also an old sanctuary of Stymphalian Artemis, the image being of wood, for the most part gilded. Near the roof of the temple have been carved, among other things, the Stymphalian birds. The Arabian desert breeds among other wild creatures birds called Stymphalian, which are quite as savage against men as lions or leopards… All armour of bronze or iron that men wear is pierced by the birds; but if they weave a garment of thick cork, the beaks of the Stymphalian birds are caught in the cork garment, just as the wings of small birds stick in bird-lime…

Pausanius, from *Description of Greece*. 2nd century CE
Tr. W. H. S. Jones (1918)

PHOENIX 🐦 Because the name phoenix is close to the Greek Phoenicia, a land famous for its purple dyes, so often associated with royalty, the phoenix came to be seen as a royal bird.

Numerous historical sources mention the phoenix, from Herodotus, fifth-century BCE 'father of history', through to medieval bestiaries. Few claimed to have actually seen the bird itself, simply reporting the tales of others. These many descriptions of the bird are often contradictory. In the Greek Apocalypse of Baruch, dated to the first century CE, Baruch describes seeing

a bird circling before the sun… And I said to the angel, What is this bird? And he said to me, This is the guardian of the earth… This bird flies alongside of the sun, and expanding his wings receives its fiery rays. For if he were not receiving them, the human race would not be preserved, nor any other living creature… His name is called Phoenix. And I said, What does he eat? And he said to me, the manna of heaven and the dew of earth.

According to some tales the bird was so big that it could stand in the deepest ocean, but in another it was simply the size of a large eagle, with a blue beak, golden feathers on its neck and red and purple feathers in its tail.

'Twas near in scope to twice the eagle's size,
With plumage iridescent, rainbow-hued.
Its breast appeared deep-dyed with purple's shade,
Its legs were red like ochre, and its neck
Was furnished round with tresses saffron-hued;
Like a coxcomb did its crest appear,
With amber-tinted eye it gazed about,
The pupil like some pomegranate seed.
Exceeding all, its voice pre-eminent.

Ezekiel, *Exagoge*. 2nd century BCE
Tr. R. G. Robertson

*Phoenix
in its Nest
Miniature
from a medieval
bestiary*

The phoenix lives a hundred years (or perhaps five hundred, perhaps a thousand…) and its home is in Araby (or India, or some other distant land); when the time comes for it to die, it strikes a flame from stone with its beak and sets fire to its nest then burns away to nothing, but in the morning a new phoenix is born from the ashes.

Not surprisingly, the phoenix became a symbol of rebirth and renaissance, even in the wake of total destruction. For the first-century Roman poet Martial, the phoenix thus represented Rome's eternity, while Christians reinterpreted the bird to symbolise Christ's resurrection.

For constancy the phoenix serves as a type: for understanding by nature its renewal it is steadfast to endure the burning flames which consume it, and then it is reborn anew.

Leonardo da Vinci (1452–1519), from *Bestiary*
Tr. Edward MacCurdy (1939)

Phoenix. Florentine mosaic table top. 18th century

46

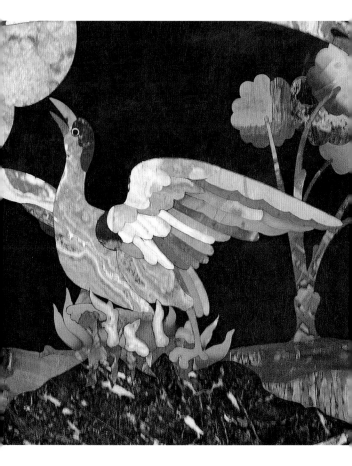

FENGHUANG Rulers of all birds in the world, the miraculous fenghuang of China is sometimes known as the Chinese phoenix, but it is in fact a composite of elements of many different birds. It is mentioned in Chinese sources dating from the sixteenth century BCE and combines both *yin* (female principle – meaning moon or hidden) and *yang* (male principle – meaning sun, light, open), for the male birds were once known as *feng* and

*Gold Hairpins
with Flying
Fenghuang
Chinese
17th–18th
century*

the females as *huang*. The fenghuang thus symbolises
marriage, harmony and perfection.

Although the fenghuang emerged from earlier
descriptions of the phoenix in Chinese culture, it is
a distinct bird: it does not die in flames to be reborn
from the ashes and indeed it is immortal. Nonetheless,
it does have associations with fire and the sun and is
sometimes shown carrying a fireball.

Not surprisingly, in Chinese cosmology, the fenghuang
is one of Four Spirits who joined the First Being Pan
Gu in creating the world, with particular responsibility
for fire, summer and the south.

49

The five colours of the fenghuang, black and white, red, green and yellow, are said to symbolise the five virtues set out by Confucius: charity and benevolence; honesty and conscientiousness; knowledge; integrity and loyalty; propriety. In part because of this the bird was used to symbolise a ruler of great honesty and virtue. The appearance of the fenghuang is said to represent peace and harmony and when paired with the (male) dragon represents marital accord. Thus we often find a fenghuang alongside a dragon on domestic objects.

Another common combination from the seventh century onwards was the fenghuang with peonies. A design known as 'fenghuang playing with peonies' or 'fenghuang passing through peonies', frequently used on woven textiles, shows the king of birds interwoven with the bloom known to the Chinese as the queen of flowers.

Although the fenghuang remained a purely Chinese bird, it 'travelled' westwards on Chinese works of art and its exotic appearance and royal symbolism led to its adoption in Persia (Iran) and on medieval Byzantine metalwork.

Fenghuang and other Birds. Chinese dish. 1750s–1760s

On pp. 52–53
Tapestry with Birds. French. Late 17th – early 18th century

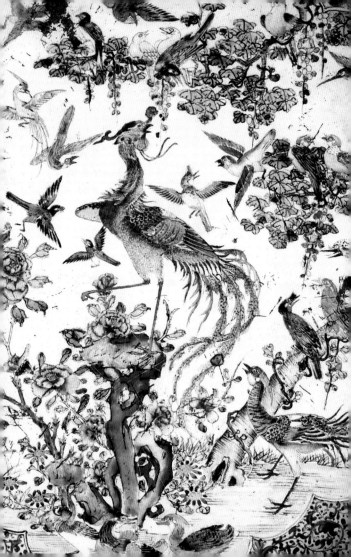

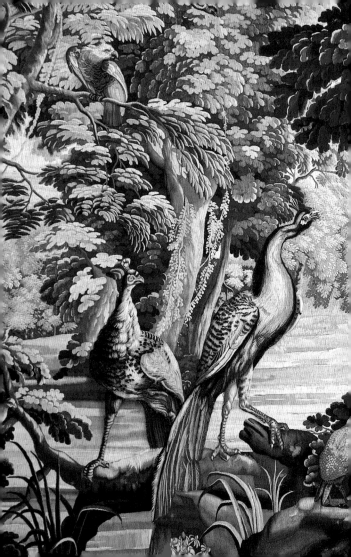

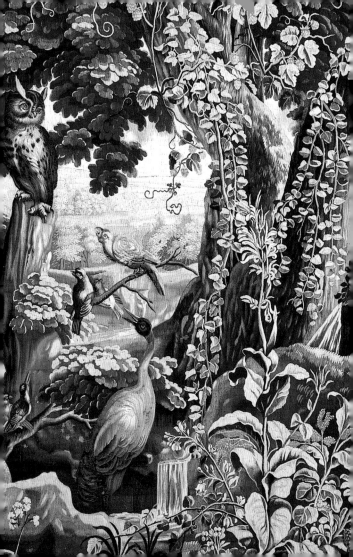

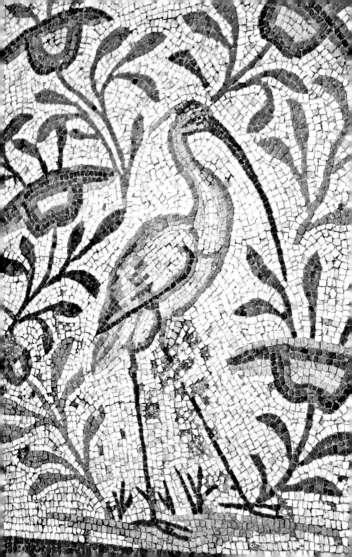

Stork

A mustering of storks. A phalanx of storks

Only two of the nearly twenty different species of stork are found in Europe, the white (*alba*) and the black (*nigra*). Three are found in the Americas, with most of the species being native to Asia and Africa.

On the roof of the last house in a little village the storks had built a nest and a mother stork sat in it with her four young ones, who stretched out their necks and pointed their black beaks, which had not yet turned red like those of their parents. A little way off, all alone on the ridge of the roof, stood the father stork, quite upright and stiff. Not liking to be quite idle, he drew up one leg and stood on the other, so still that it almost seemed as if he were carved from wood. 'It must look very grand for my wife to have a sentry guarding her nest!' he thought. 'People don't know I am her husband; they'll think I am a servant, commanded to stand here on guard, which is very smart.' So he went on standing on one leg.

Hans Christian Andersen, from *The Storks*. 1838

Stork
Libyan mosaic
2nd century

Despite their relative rarity in Europe, folklore has
the stork as deliverer of new babies: all across
the western part of the continent we find depictions
of storks clasping in its beak a basket or cloth in
which is wrapped a baby. Although this
tradition of linking the stork with parenthood
is longstanding, its popularity grew after the
publication of Hans Christian Andersen's fairytale.
Storks live very close to human civilisation and are
thought to be monogamous. In many ways they
represent the ideal of marital harmony. Male storks
are among the first to return to the northern regions
in the spring from Africa, where they spend the winter.
Flying huge distances each day, they hurry back to
find their nest from the previous year, evicting any
'squatters' (such as sparrows and starlings), getting
rid of rubbish and replacing old twigs with new.
When everything is ready, the male stands waiting
in the nest, head and neck stretched upwards as
he clicks his beak to signal to the returning female.
Once eggs have been laid, most of the time it is
the father who sits on them, the mother taking over
only at night. Both are responsible for feeding
the chicks, however, with small frogs and mice and
lizards, or even snakes. Hence medieval bestiaries
and books of emblems sometimes show a stork with
a snake dangling from its beak. Just such a stork was

Stork
Medieval
miniature
French
13th century

Publisher's Mark
of Matthäus
Merian
German
engraving
1650s

chosen by the seventeenth-century German engraver and publisher Matthäus Merian as his own printer's mark. The words *Ciconia Meriani* (Merian's stork) appear above it, framed with a Latin device, *PIETAS CONTENTA LUCRATUR*, which means 'Industrious piety pays' (although the word *pietas* covered a wide variety of human virtues at that time, from honesty and openness to loyalty, charity and selflessness). In the East, meanwhile, the stork is a symbol of longevity, and in Taoism of immortality.

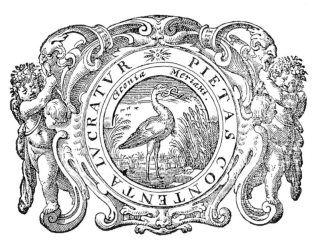

Raven

A congress of ravens. A conspiracy of ravens

By far the heaviest of the passerines or perching birds, which have three toes forwards and one back, acting independently like a thumb, is the northern raven. It is this bird of all the corvids (crows, from the Latin *corvus* meaning raven) that seems to be most firmly interwoven with ancient perceptions of the origins of the world. Tales of the raven are found amongst the indigenous peoples of North America, Alaska, Greenland, Chukhotka and Kamchatka. Here the black raven is a magical figure, creator and organiser of the universe, who teaches mankind how to build houses, to hunt, create fire and make clothes. He can change form and become human or animal.

It was to the Great Raven that people prayed when sick or in need or protection, using ritual dances and raven masks and feathers to bring success in the hunt. Amongst the oldest myths is the Paleo-Asian tale of the raven who pecked a hole in the heavens in order to let light through to shine down on mankind. According to the Sioux, the raven was originally white but he angered a shaman, who threw the bird into a fire, where his feathers were burned to black.

Raven
Scythian finial
4th century BCE

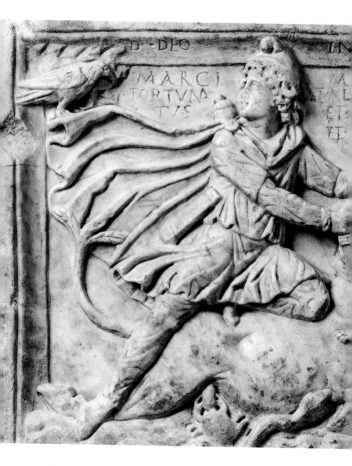

Ravens served the Greek god of the sun, Apollo, and were the companions of the Indo-Persian Mithra, god of light, who came to be revered throughout the Hellenic world after Alexander the Great defeated the Persians. On a Roman marble relief with a scene of *tauroctony* (Mithras – as Mithra was known to the Ancient Romans – sacrificing a bull), we see a raven observing the scene: the ritual symbolises male fertility, since the blood and semen (drawn by a scorpion) sink into the ground and make it fertile. The raven also plays its part in the Christian Bible, being one of three birds – the others are the swallow and the dove – sent out from Noah's Ark to see if the waters of the Flood had subsided. And when the rains dried up the prophet Elijah was ordered by God to sit by the brook Cherith, where ravens were sent to feed him. A raven, along with two lions and a palm tree, is an attribute of Saint Paul of Thebes. Paul lived a hermit's life, alone in a cave in Egypt, his daily bread brought to him by the raven.

Mithras and the Tauroctony. Roman relief. 2nd century

But from the medieval period ravens came to be a symbol of bad luck, even of evil, in European and Slavic mythology. In the early thirteenth-century Norse epic known as the Prose Edda a raven appears in terrible form, with iron claws and beak and with a single eye, marking it out as a chthonic being, tied to the world of the dead. Amongst the familiars of the supreme Germano-Norse god Odin are two ravens who sit upon his shoulder, Hugin (thought) and Munin (memory).

At dawn the ravens fly off and travel the world (or worlds – Norse mythology mentions nine worlds), returning in the evening to relate everything they have seen.

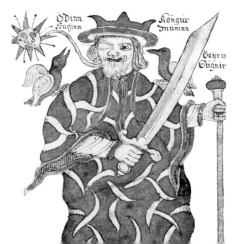

*Odin
and his Ravens
Norse manuscript
1765–66*

Ravens are scavengers and a number of traditional songs and poems in England, Scotland and Denmark capture their thoughts as they sit in a tree contemplating a dead knight. According to the Scottish version, famously rendered by Walter Scott, two ravens (*corbies*) gleefully note that the master has been abandoned by hawk and hounds and even his lady has found a different love, leaving the field free for a tasty meal.

O'er his bones when they are bare
The wind shall blow for evermair…

Ravens
on an Oak Tree
Ivan Bilibin
Russian. 1902

This version was translated into Russian by Alexander Pushkin in 1828.

But the English song is more optimistic: here
the knight's loved ones stay faithful, depriving
the ravens of their meal.

There were three ravens sat on a tree,
They were as black as they might be.
The one of them said to his mate,
Where shall we our breakfast take?
Down in yonder green field,
There lies a Knight slain under his shield,
His hounds they lie down at his feet,
So well they can their Master keep,
His hawks they fly so eagerly,
There's no fowl dare him come nie
Down there comes a fallow doe,
As great with young as she might go,
She lift up his blood head,
And she kissed his wounds so red,
She got him up upon her back,
And carried him to earthen lake,
She buried him before the prime,
She was dead herself ere even-time,
God send every gentleman,
Such hawkes, such hounds, and such a leman.

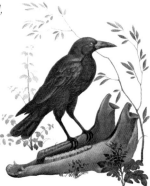

Traditional folk song

Why can I not the raven be,
That just now did fly above me?
Why can I not glide the sky?
Loving freedom as I fly?
Westward, westward would I hasten,
 Where flourish my ancestral lands,
To the empty castle 'midst mountains misty,
 Where in oblivion they lie.
Armorial shield and rusted sword
 Hang upon the ancient wall.
Over sword and shield I'd fly,
 Sweep the dust hence with my wing;
I'd strum the strings of a Scottish harp,
The sound would swell up in the vaults;
Struck by one, heard by one alone,
Fading just as it was born.
But vain are my hopes, vain my prayers,
'Gainst the unbending laws of fate.
For billowing seas divide me forever
 From the hills of my native land.
Last in a line of brave, daring warriors,
 I wither away 'midst the alien snows;
Here was I born, but my heart is not here.
 O why can I not the raven be?

Raven
From the
Raphael Loggia
in the Hermitage
1778–88

Mikhail Lermontov, *Yearning.* 1831

In Japan the raven is also associated with the
underworld, seen as the conductor between
the world of the living and the world of the dead.
In the Mezurashizuka tomb in Fukuoka Prefecture,
there are wall paintings showing a burial boat with
a raven on the prow and a man at the stern. Behind
is the sun and ahead is the moon: the raven is thus
leading the boat to the kingdom of the dead. Tengu
are legendary Japanese creatures, one kind of which
is the *karasu-tengu*, the crow or raven tengu, with
a human body but the wings, claws and powerful
beak of a corvid. Strong, aggressive and peevish,
they are always ready to play tricks on humankind.
In China, however, the raven is a bird of the soul,
the skies, the sun. A red raven was the symbol of the
ancient Zhou Dynasty (eleventh to third centuries
BCE), while for the Manchu people a raven
represents the spirit of an ancestor.

Tengu Emerging
from its Egg
Masa Shumin
Japanese netsuke
19th century

The raven is in flight,
tossing in the twilight
a wintry tree.

Natsume Sōseki (1867–1916)
Tr. anon.

On a withered branch
now sits a raven darkly.
Autumn night has fallen.

Matsuo Bashō (1644–94)
Tr. anon.

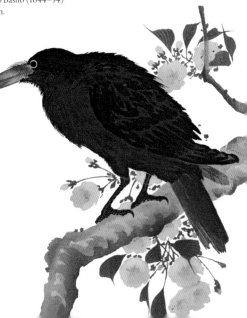

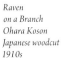

Raven
on a Branch
Ohara Koson
Japanese woodcut
1910s

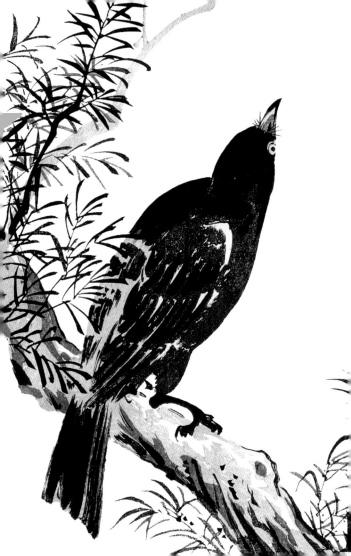

Ravens of all kinds, including the northern raven that is so common in the northern hemisphere, are simply the largest of the corvids, a family that includes crows, rooks, jackdaws, jays and magpies. And of all the corvids it is the raven that has most often been kept as a pet or companion. Monogamous in its mating, the raven also remains loyal to any adopted 'owner'. Not only can it imitate the calls of other birds but, if carefully taught, can repeat words and likes to engage in playful behaviour. Sometimes it can almost seem, well, human.

Charles Dickens had a pet raven that served as the model for the raven in his novel *Barnaby Rudge* (1841). Anyone who has watched a raven will recognise the portrait he drew:

After a short survey of the ground, and a few sidelong looks at the ceiling and at everybody present in turn he fluttered to the floor, and went to Barnaby – not in a hop, or walk, or run, but in a pace like that of a very particular gentleman with exceedingly tight boots on, trying to walk fast over loose pebbles.

The Lonely Raven. From the album Flowers and Birds Japanese woodcut. 19th century

Closely related to the raven is the crow, although
crows are not all entirely black. In many regions crows
have black heads and wings but a grey body.

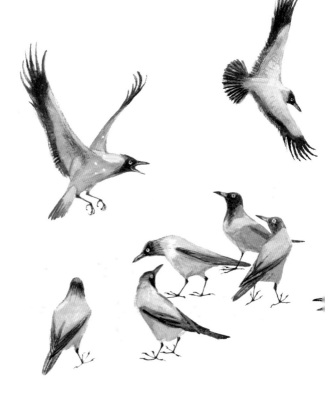

On the Indian subcontinent, for instance, the house crow (*corvus splendens*) dominates, while in north-eastern Europe and Eurasia it is the hooded crow (*corvus cornix*) that is most familiar.

Although all corvids are highly sociable birds, crows tend to gather in large groups, while ravens prefer to move in pairs. And if the crow makes a repetitive purring 'caw', ravens make a honking croak.

Despite their many differences, ravens and crows are united by their curiosity and their considerable intelligence. In his *Natural History*, Pliny (first century CE), noted the crow's ability to work out how to crack a hard nut by dropping it from a great height, and ornithologists have observed how in modern times all the corvids have proved extremely inventive in adapting man-made materials (mainly rubbish picked up on the street or in dumps) to build their nests in the most unusual places.

Whether monochrome like ravens and crows, or colourful like jays, corvids are ubiquitous, an integral part of the landscape and the soundscape: their guttural cries in the wild are often associated with melancholy, even while their skill in speaking when domesticated is often a source of joy.

Crows. Nikolay Ustinov. Russian watercolour. 1980s

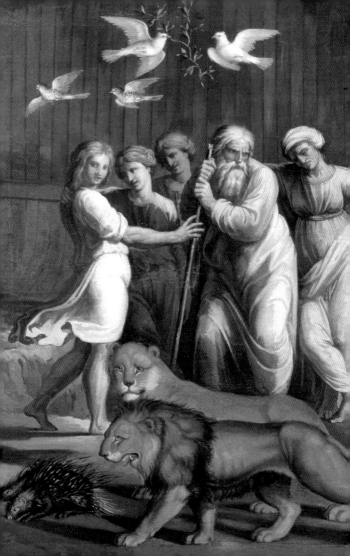

Dove

A dole of doves. A piteousness of doves. A bevy of doves

The genus *columba* covers all kinds of doves and
pigeons, from the dainty, purring turtle dove to
the feral pigeon. While the word 'pigeon' is all too
often associated today with the birds that have
become a pest in modern cities across the world,
'doves' are almost universally a symbol of love
and goodness.

The dove's central – and positive – role is seen even
in the earliest written sources. *The Epic of Gilgamesh*,
written some five thousand years ago in Mesopotamia,
includes the tale of Utnapishtim, who builds a boat
to escape a flood and sends out a dove to find out if
the waters have receded and dry land has appeared.
This is the precursor of the Old Testament tale of
Noah, who also sent out a dove from the Ark. When
the dove returned on the third day with an olive
branch in its beak, Noah knew that he could seek
land for his family and all the animals in his ark
to disembark and build a new life. This was a symbol
that God had forgiven mankind its sins and thus
both the dove and the olive branch have become
a symbol of peace the world over.

The Saved
Leaving
Noah's Ark
From the
Raphael Loggia
in the Hermitage
1778–88

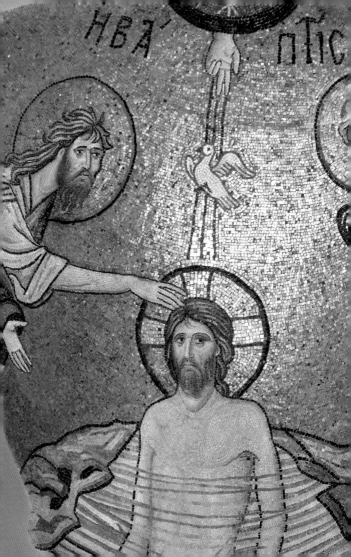

*When an ant went down to the bank of a river to quench
its thirst, it was almost carried away by the rushing stream.
Just as it was on the point of drowning, a dove sitting on
a tree overhanging the water plucked a leaf and let it fall
into the stream close by. The ant climbed onto it and
floated safely to the bank. Shortly afterwards a birdcatcher
came and stood beneath the tree, laying a trap for the
dove sat overhead in the branches. Perceiving his design,
the ant stung him in the foot and the birdcatcher started
in pain and surprise. Frightened, the dove took wing
and was saved.*

Aesop, *The Ant and the Dove*. 6th century BCE. Tr. anon.

Doves also represent the human soul, the spirit, and in
the Christian faith the Holy Spirit (part of the Trinity
of God the Father, God the Son and God the Holy
Spirit) is represented by a dove.

*The Baptism of Christ. Mosaic. Daphni Monastery,
near Athens. Greek. Second half of the 11th century*

On pp. 76–77
The Annunciation. Jehan Bellegambe. Netherlandish. 1516–17

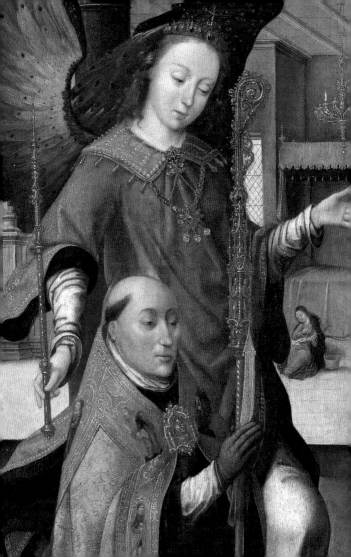

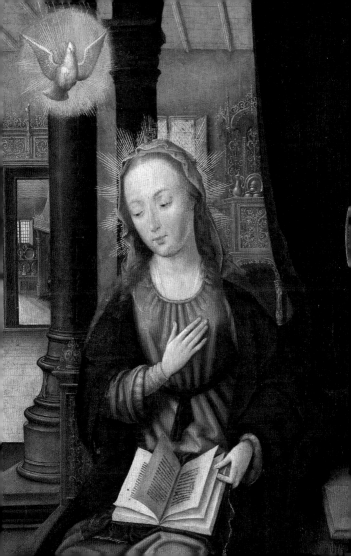

As symbols of fertility and purification, doves feature as early as 4000 BCE, representing the Sumerian mother goddess Inanna and the Assyrian Ishtar. Indeed, *hu* or dove was the word used to describe women devotees of Ishtar. Doves also accompany the Ancient Greek goddess of love Aphrodite (Roman goddess Venus). Across different religions, past and present, white doves are often released at weddings to symbolise love and fidelity, but also at funerals, to represent the soul's release from its earthly 'prison'.

Steel Dove
Haji Abbas
Persian. Late
19th – early
20th century

In the thirteenth century Bartholomaeus Anglicus recorded that in Egypt and Syria doves (pigeons) were taught to carry letters home:

For the bird loveth kindly the place and the dwelling where it was first fed and nourished. And be it never so far borne into far countries, always it will return home again, if it be restored to freedom. And oft to such a pigeon a letter is craftily bound under the one wing, and then it is let go. Then it flieth up into the air, and ceaseth never till it come to the first place in which it was bred.

Carrier or homing pigeons, as we know them today, might take a request for help out of a besieged city, and they played a vital role in getting messages through enemy lines in times of war from Antiquity through to the twentieth century. In the Second World War, 32 carrier pigeons received British medals for service in wartime! Pigeons are said to have spread news of the results of the Olympic Games in Ancient Greece. The pigeon post played a role in commerce and diplomacy and royal courts frequently had carrier pigeons that diplomats could take on an embassy to release with a secret message. Not surprisingly, this method of conveying secrets has also been used extensively by spies throughout the ages…

It was not just – or mainly – as 'postmen' that doves were farmed, housed in special tall narrow structures (often round), introduced to Europe by the Romans, that came to be known as dovecotes. The form of the dovecote, the upper inner surface covered with numerous niches, provided a place for the birds to roost up above while allowing for the collecting not only of their eggs but of the dung that accumulated on the floor within: dove dung makes an excellent fertilizer ('No manure makes the corn more strongly rise, Or the grass please with brighter green the eyes'). The birds were also eaten – roasted, stuffed and in pies (although such pies are known as 'pigeon pie', never as 'dove pie').

The Latin word for a dovecote is *columbarium* but today that term is used for a cemetery wall filled with niches, very like the inside of a dovecote, in which urns containing ashes are housed.

The Family of Adam Johann Sadeler, after Maerten de Vos. Flemish engraving. 1586

Gold Earring with Doves Olbia, Northern Black Sea Region 4th century BCE

On pp. 82–83 Mosaic. Church of Santa Maria in Trastevere, Rome. Italian 12th–13th century

You'd think one will did all their breasts inspire,
So uniform's the gentle kind's desire;
They feed together, and together fly,
You'll see them sail along the crowded sky,
Whether they to the sheafy field repair
For food, or wantonly they sport in air…
Thus, if small things with great I may compare,
The dove lives free from guilt, and void of care;
Nor ever sees with grief the quiet state
Destroy'd by jealousy and factious hate,
Those passions which the human bosom tear,
And fill the world with slaughter, rage, and fear…

But who with equal praise can e'er commend
The care with which their unfledged young they tend?
For first, the parents bare their feather'd breast,
To make more light with the soft down the next …
And when the young are from their prison freed,
They both alike to the joint task succeed …
But what exalts the dove's unrival'd praise,
And consecrates her in the poet's lays,
Is that fidelity in love, we find
So very rarely in the human kin.
Their faith they keep inviolate to death,
And sigh out their true souls in the last breath.

Anonymous, from *The Dove-cote.* 1740

On the hill-side, yonder where are the graves,
A fine palm-tree, like a green plume,
Stands with head erect; in the evening the doves
Come to nestle under its cover.

But in the morning they leave the branches;
Like a spreading necklace, they may be seen
Scattering in the blue air, perfectly white,
And settling farther upon some roof.

My soul is the tree where every eve, as they,
White swarms of mad visions
Fall from heaven, with fluttering wings,
To fly away with the first rays.

Théophile Gautier, *The Doves*. 1838
Tr. Robert Sanderson

The Amusements of Youth. Juste Chevillet,
after Pierre-Alexandre Wille. French engraving. 1773

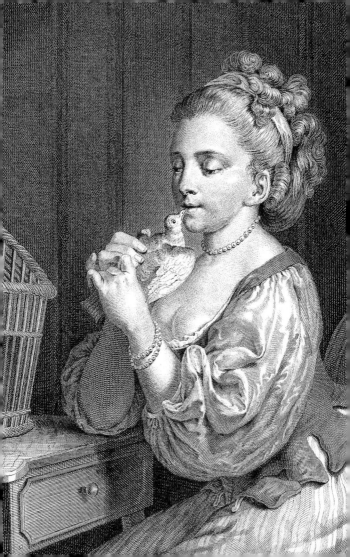

Poor restless dove, I pity thee;
And when I hear thy plaintive moan,
I mourn for thy captivity,
And in thy woes forget mine own.

To see thee stand prepared to fly,
And flap those useless wings of thine,
And gaze into the distant sky,
Would melt a harder heart than mine.

In vain—in vain! Thou canst not rise
Thy prison roof confines thee there;
Its slender wires delude thine eyes,
And quench thy longings with despair .

Oh, thou wert made to wander free
In sunny mead and shady grove,
And far beyond the rolling sea,
In distant climes, at will to rove!

Yet, hadst thou but one gentle mate
Thy little drooping heart to cheer,
And share with thee thy captive state,
Thou couldst be happy even there.

Gold Earring
with Dove
Pendant
Bosporan
Kingdom
2nd century BCE

Pliny's Doves
Italian mosaic
Late 18th – early
19th century

Yes, even there, if, listening by,
One faithful dear companion stood,
While gazing on her full bright eye,
Thou might'st forget thy native wood.

But thou, poor solitary dove,
Must make, unheard, thy joyless moan;
The heart that Nature formed to love
Must pine, neglected, and alone.

Anne Brontë,
The Captive Dove. 1843

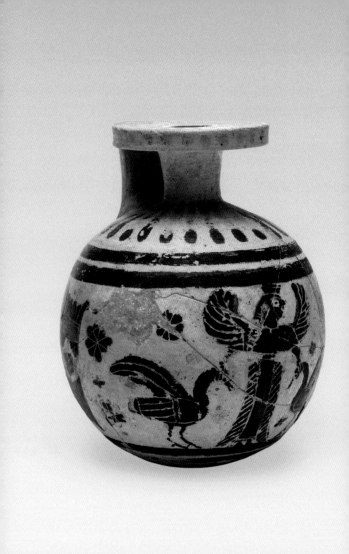

Goose

A gaggle of geese. A plump of geese. A skein of geese

It was said that Rome was saved from invasion around the year 390 BCE by the cackling of the geese warning of the enemy's approach. Certainly geese were prized from ancient times. Add to their value as 'guard dogs' the fact that every part of the goose is useful – its meat, its eggs, its feathers and down – and there is no surprise that geese have been domesticated since early in human history. They appear in Egyptian paintings and carvings dating from the third millennium BCE, in which we see the red-breasted geese who are today commonly known as Egyptian geese. Domesticated geese apparently reached Europe some time in the first millennium. Thereafter, geese became increasingly present not just physically but as a point of cultural reference. Penelope, abandoned wife of Ulysses, tends a flock of geese in *The Odyssey*, the Greek tale written in the eighth or early seventh century BCE.
A goose was one of the attributes of Greek goddess Hera (Roman Juno), perhaps emphasising her domestic aspect. Even today, a fat white goose is the epitome of the well-kept smallholding or farm and the well-fed household.

Artemis, Mistress of the Birds
Corinthian black-figure vase
Late 7th century BCE

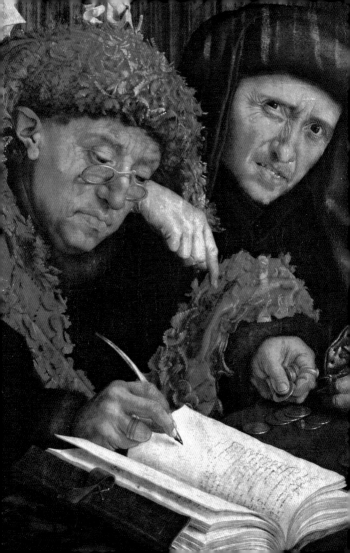

In the sixth century a new purpose was discovered for goose feathers: they could be made into excellent pens. Because of the way the bird's wing curves, the most suitable feathers (for right-handed users) come from the outer rows of the left wing. The barbs are removed and the quill must be tempered in hot sand or ashes to make it hard and resistant to wear, before it is sharpened with the knife of a type now known as a pen-knife. Quills require regular sharpening, just like pencils.

Although metal pen nibs went into mass-production in 1822, the year after he was born, Gustave Flaubert preferred to write with a goose quill, perhaps as much for effect as because he liked the feel. Goose quill pens remained in use for part of the nineteenth century but are now the preserve of artists and calligraphers.

Annuity Vendors
Marinus
van Reymerswale
Netherlandish
c. 1538

Goose Quill Pen
Jan van de Velde
Dutch woodcut
1605

With so much demand for geese it is no surprise that they were often taken long distances to market. Not just to a local market, but to big livestock markets where animals and birds could fetch a better price. Cattle and fowl were herded along stony roads for perhaps 150 km. To protect their feet cattle were given temporary metal shoes and turkey were shod with little leather boots. Geese, however, rejected any attempt to put boots on them, giving rise to the phrase 'to shoe a goose', meaning to try and do something utterly futile. The only way to give their webbed feet the protection needed was to drive the flock through melted tar and then through sand, which gave their feet a hard, resistant coating. Although when you think that in the first century Pliny recorded the Gauls driving geese from northern France and Belgium to Rome – a distance of over 1,500 km, with such geese herds moving along at just thirteen or fourteen km a day – it becomes clear that this process probably had to be repeated several times on the journey. Geese's short temper and ability to cause great damage with their beaks when provoked led to the use of sheepdogs to herd them to market in Central Europe in the nineteenth century.

Rural Festival. Hans Wertinger. German. c. 1525

The barnacle goose gets its name because it was once thought to be a mysterious creature that clung to surfaces like a barnacle or limpet:

There are many birds called Bernacae. They are produced from fir timber tossed along the sea and are at first like gum. Afterwards they hang down by their beaks as if they were seaweed attached to the timber. Having thus been clothed with a strong coat of feathers they either fall into the water or fly freely away… I have frequently seen, with my own eyes, more than a thousand of these small birds, hanging down on the sea-shore from one piece of timber.

Gerald of Wales, from *The History and Topography of Ireland.* 1185

Wild geese migrate to more temperate climes in
the winter and Charles Darwin recorded the story
of one Brent goose with clipped wings whose natural
instincts were so strong that it tried to walk away
when the time came for its fellow geese to fly south.
Though domestic geese can fly, they are hampered
by the heavy fat deposits around their rear that make
them such a rich feast when roasted. They reach
their maximum weight in about the beginning of
November and by tradition in northern Europe
the fatted goose was killed for St Martin's day,
11 November, which marked the end of the autumn
works on the land. New-pressed wine was drunk
and the goose stuffed with cabbage or apple. Later
the stuffed goose was to be the traditional
Christmas dish.

*There never was such a goose. Its tenderness and
flavour, size and cheapness, were the themes of universal
admiration. Eked out by apple-sauce and mashed
potatoes, it was a sufficient dinner for the whole family…
The youngest Cratchits in particular were steeped in sage
and onion to the eyebrows.*

Charles Dickens, from *A Christmas Carol.* 1843

Goose, goose, goose,
Neck bent, singing to the sky.
White feathers floating on emerald waters.
Red feet paddling amidst the clear waves.

Luo Binwang (active 627–84). Tr. anon.

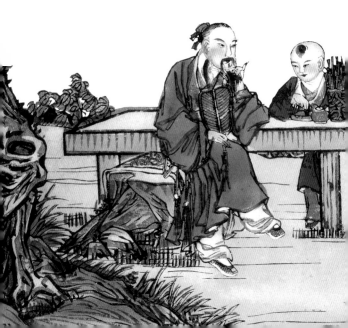

If doves symbolise marital fidelity in some cultures, their place is taken in China by geese. One traditional Chinese wedding gift is a pair of geese: a gander for the groom and a goose for the wife. But wild geese set off a train of more romantic associations for both Chinese and Japanese poets. As the geese fly away, the poet laments lost love, but when they return, there is the joy of reunion. Or the author simply gives himself up to purely aesthetic admiration of the beauty of their formation and the graceful smoothness of their passage through the sky. The Japanese poet Kobayashi Issa wrote nearly 450 haiku about geese alone!

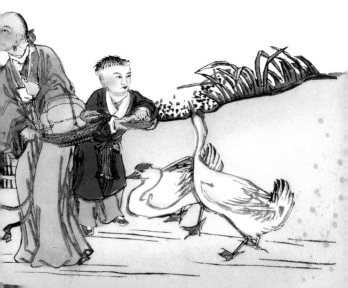

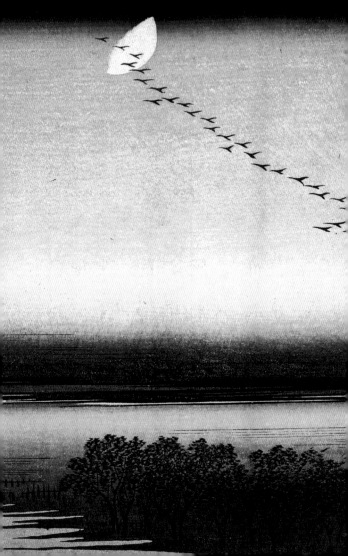

The sea darkening –
The voices of the wild geese
Crying, whirling, white.

Saigyo (1118–90). Tr. anon.

From this day forth, geese,
you are Japanese.
Now enjoy your rest.

Kobayashi Issa (1763–1828)
Tr. anon.

Low over the railroad
wild geese flying –
a moonlit night.

Masaoka Shiki (1867–1902)
Tr. R. H. Blyth

The Nihon Embankment in Yoshiwara. Hiroshige. Japanese woodcut. 1857

Flying Goose. Maekawa Bunrei. Japanese woodcut. 1885

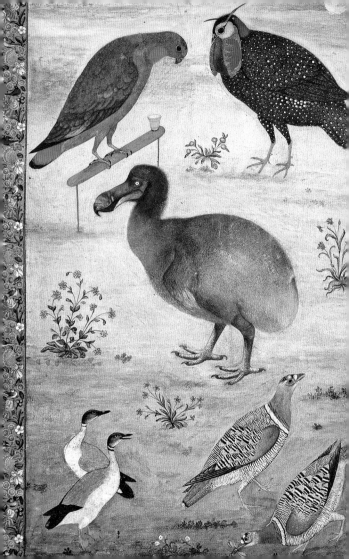

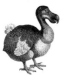

Dodo

If it were not for Lewis Carroll, who made the dodo one of the characters in *Alice's Adventures in Wonderland*, this bird (a kind of pigeon!) might well have remained known only to specialists in long-extinct species. First recorded in 1598 by Dutch sailors visiting the island of Mauritius, the last verifiable sighting was less than century later, in 1662. In that short space of time, it had made its impression on a number of travellers and explorers. In 1638, one specimen was even supposedly brought to London. Sir Hamon Lestrange recalled paying to see 'a great fowle',

Dodo
Indian miniature
17th century

On pp. 102–3
The Dutch
on Mauritius
Dutch engraving
1601

somewhat bigger than the largest Turkey Cock,
and so legged and footed, but stouter and thicker and
of a more erect shape, coloured before like the breast of
a young cock pheasant, and on the back of dunn or deare
colour. The keeper called it a Dodo, and in the ende of
a chymney in the chamber there lay a heape of large pebble
stones, whereof he gave it many in our sight, some as
big as nutmegs, and the keeper told us she eats them
(conducing to digestion).

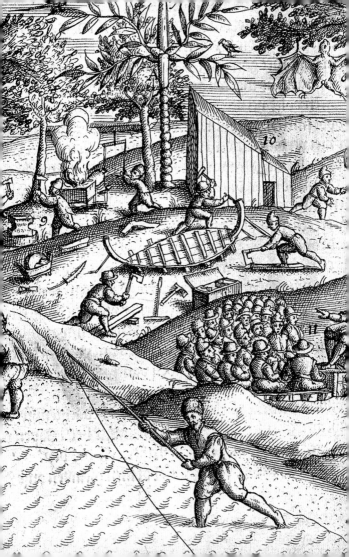

It is only from contemporary records and from
the few skeletons and other remains in museums
that we can make any attempt to reconstruct
the dodo's appearance and habits. Safe on its island,
free of natural predators, this rather dumpy bird made
little effort to escape when sailors came on shore
to replenish their food stores. Although its meat was
widely declared to be tasteless, it was much hunted
and its habitat destroyed, and within a few decades
of its 'discovery' it had become extinct. Hence
the saying 'as dead as a Dodo'.

*They began running when they liked, and left off when
they liked, so that it was not easy to know when the race
was over. However, when they had been running half
an hour or so… the Dodo suddenly called out 'The race
is over!' and they all crowded round it, panting, and
asking, 'But who has won?'*
*This question the Dodo could not answer without
a great deal of thought, and it sat for a long time with
one finger pressed upon its forehead… At last the Dodo
said, 'everybody has won, and all must have prizes.'*
'But who is to give the prizes?' quite a chorus of voices asked.
*'Why, she, of course,' said the Dodo, pointing to Alice with
one finger; and the whole party at once crowded round her,
calling out in a confused way, 'Prizes! Prizes!'*

Alice had no idea what to do, and in despair she put her
hand in her pocket, and pulled out a box of comfits…
and handed them round as prizes. There was exactly
one a-piece all round.
'But she must have a prize herself, you know,' said the Mouse.
'Of course,' the Dodo replied very gravely. 'What else have
you got in your pocket?' he went on, turning to Alice.
'Only a thimble,' said Alice sadly.
'Hand it over here,' said the Dodo.
Then they all crowded round her once more, while
the Dodo solemnly presented the thimble, saying 'We beg
your acceptance of this elegant thimble'; and, when it had
finished this short speech, they all cheered.

Lewis Carroll,
from *Alice's Adventures in Wonderland*. 1865

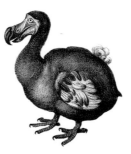

Dodo
William Hodges
British. 1773

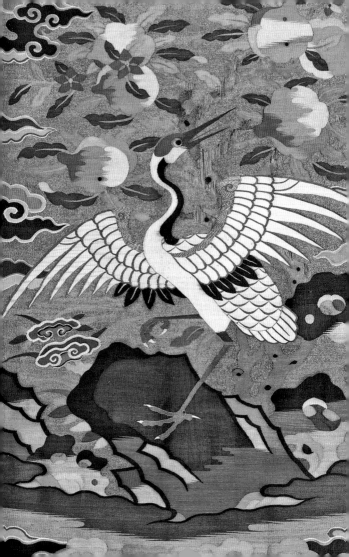

Crane

A sedge of cranes. A dance of cranes. A swoop of cranes

Cranes have captured the imagination of peoples from time immemorial and the sight of a sedge of cranes moving effortlessly through the skies on its way to or from lands unknown seemed to epitomise the mysteries of life. It is surely no surprise, therefore, that images of cranes dating from the Neolithic period are among the oldest depictions of a recognisable bird. The symbolism of cranes is most developed in China and Japan, where a flying crane was thought to carry the souls of the dead up to heaven.

I hear the black cranes crying in the morning
On the towering summits of the lofty mountains.
Alone with my growing anger, by turns glad and grieving,
I hover through the islets, singing softly.

Liu Xiang (77–6 BCE), from *Saddened by Sufferings*
Tr. David Hawkes (1959)

Crane
Chinese silk panel
Late 16th – early
17th century

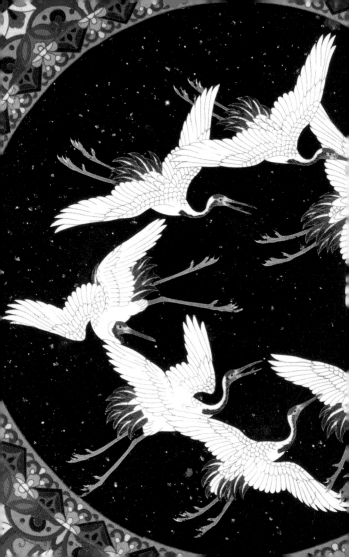

Despite such melancholy associations, the Chinese word for crane is also a homophone for *hé*, harmony, and cranes could symbolise nobility, marital fidelity and high position. Indeed, one Chinese saying, 'A crane standing amidst a flock of chickens', means to be superior, to stand out amongst the crowd. Although mostly found in Korea and China, and even in far eastern Russia, the red-crowned crane that appears in so many Asian works of art is known as *grus japonensis*. Today it is revered on Hokkaido, the northernmost of the Japanese islands, where there are about a thousand birds: over a third of the world population of red-crowned cranes. After it was realised in the 1920s that there were just twenty breeding birds left on Hokkaido a concentrated programme to save this threatened species was begun. Today, Hokkaido has adopted the crane as its symbol: the local ice hockey team is known as The Cranes and even the airport at Kushiro is known as Tancho (crane) Airport. Red-crowned cranes do not migrate very far, which perhaps is one reason why they are so associated with permanence and constancy. Cranes were embroidered on wedding kimonos in Japan as a symbol of a long and happy marriage.

Flying Cranes. Japanese dish. 19th century

One ancient Japanese legend states that those who
fold a thousand origami cranes (*senbazuru*) will earn
the granting of a wish, and today strings of a thousand
cranes folded from brightly coloured paper are
a traditional temple donation, a prayer for peace
or a gift of well-wishing to someone who is ill.

Rainy season
and the crane's legs
have grown shorter.

Matsuo Bashō
(1644–94). Tr. anon.

The cold, windswept sky,
I look up at it once more,
hearing the crane's cry.

Mukai Kyorai (1651–1704)
Tr. anon.

Red-crowned Cranes. Hiroshige. Japanese woodcut. 1857

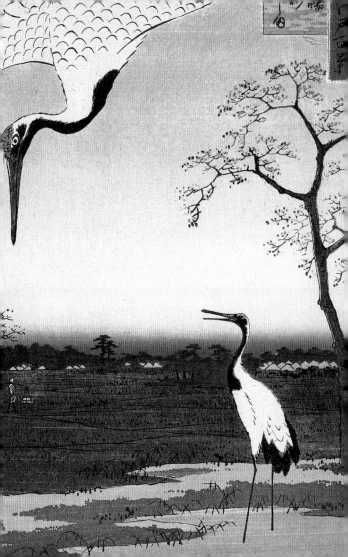

Despite ancient descriptions that show
cranes to have been revered, their
beautiful mating dances a source of joy,
these birds have been hunted and eaten
for centuries. In Ancient Greece,
the brains of cranes were thought to be an
aphrodisiac! In southern Africa, the blue
crane suffered because its feathers were
associated with masculinity and fighting
skills, and so were worn by kings and
warriors. Thus of fifteen types of crane,
nine are now threatened with extinction,
the result of destruction of their habitat
and uncontrolled hunting.

In his celebrated book known as *The Art
of Falconry,* Holy Roman Emperor
Frederick II (1194–1250) devoted a
whole 29 chapters to 'crane hawking', or
the best way to catch cranes. He covered
in great detail the best season and weather,
discussing the different birds of prey and
which was most suited to catching cranes
and their young.

Crane. French miniature. c. 1500

112

Medieval bestiaries describe cranes as sociable birds,
living happily in the company of each other, ruled
by a leader to whom they are obedient (thus being
a symbol of an ideal feudal society!). When a flock
of cranes needed to rest, said medieval authors, some
would sleep while others stood on watch upon one
leg, the other holding a stone high above the ground,
so that if they fell asleep it would fall and wake them.
Which is how cranes were often depicted, holding
a stone in one raised foot.

Crane
Italian tomb relief
1802

A haze of smoke hangs near the barn
Where the damp hay is drying,
And with a long and lingering gaze
We watch the slow cranes flying.
They fly across the sky obliquely,
Their leader's wailing, keening…
But why, but why that autumn cry?
Say, what can be its meaning?

Alexander Blok, *Autumn Day*. 1909
Tr. Alex Miller (1981)

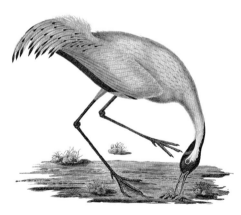

Line of Cranes
Valentin Kurdov
Russian
lithograph. 1930s

Common Crane
Pyotr Borisov
Russian
First half of
the 19th century

On pp. 116–17
Well. Dutch tile
18th century

114

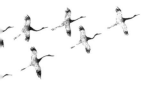

Cranes are associated with the Greek sixth-century poet Ibycus, who was killed by bandits but whose murderers were, according to legend, identified by the crying of the cranes.

'And must I in a foreign land,
Unwept, deserted, perish here,
Falling beneath a murderous hand,
Where no avenger can appear?'
Deep-wounded, down he sinks at last,
When, lo! the cranes' wings rustle past.
He hears, though he no more can see,
Their voices screaming fearfully.
'By you, ye cranes, that soar on high,
If not another voice is heard,
Be borne to heaven my murder-cry!'
He speaks, and dies, too, on the word.

Friedrich von Schiller,
from *The Cranes of Ibycus*. 1797. Tr. anon.

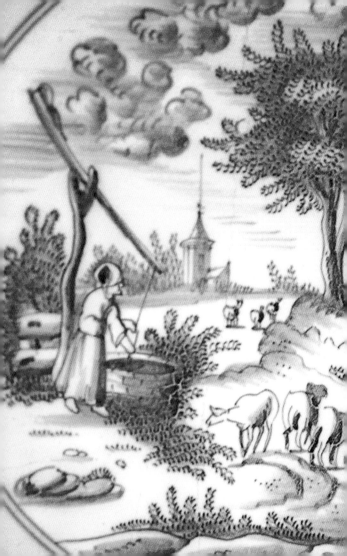

Cranes are tall birds, the sarus crane reaching up to
1.7 m high, and because of the way they move across
wet surfaces, picking their feet up out of water rather
than wading, they somehow seem to be particularly
stately and dignified.

The height and long necks of cranes led to the use
of their name for a variety of tall lifting devices. In
Russia, a shadoof (or counterpoise lift) well is known
as a crane, but in English, French, German and many
other languages, a crane is a large piece of lifting
machinery. In Finland there is a similar association
with lifting, since traditional belief held that the crane
was responsible for holding up the sky. Thus the ridge
beam of a peasant house is known as a crane log.

*Let us be merciful as the cranes; that, placing ourselves
on a lofty watch-tower in this life, we may look out both
for ourselves and for others, may lead those that are
ignorant of the way, and may chastise the slothful and
negligent by our exhortations. Let us take turns in our
labours. Let us carry the weak and infirm, that they faint
not in the way. In the watches of the night, let us keep
vigil to the Lord, by prayer and contemplation.*

St Anthony of Padua, from *Sermons*. 1220s
Tr. John Mason Neale (1856)

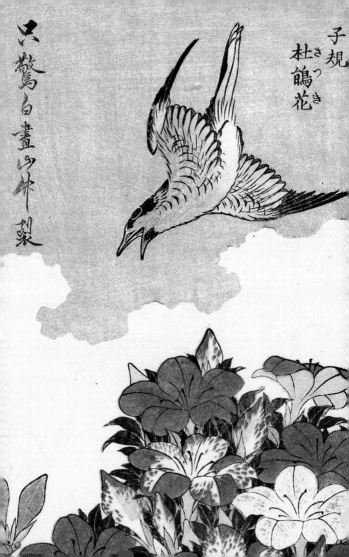

子規
杜鵑花
さつき

Cuckoo

The swallow and the cuckoo are rivals as the first sign of spring. Is it the swallow soaring and swooping or the call of the cuckoo in the woods that tells us that spring is really here? A thirteenth-century English song called 'Sumer is icumen in' (Summer is a'coming in) calls on everyone to join in the chorus, 'Sing cuckoo!' Thus some early spring flowers bear the bird's name: cuckoo pint (*arum maculatum*) and cuckoo flower (*cardamine pratensis*), although there is also the less romantic foam surrounding the nymph of the froghopper insect on plant stems that is commonly called cuckoo spit.

Yet that repetitive call on two notes has also led to an association with loneliness and melancholy and in some cultures the cuckoo is thought to accompany the soul of the dead into the next world. In Japan, the cuckoo encapsulates the mood of one suffering from unrequited love.

*Cuckoo and
Azaleas
Hokusai
Japanese woodcut
1834*

How long did I wait
for the cuckoo to sing forth
in this very year

Kobayashi Issa (1762–1828)
Tr. anon.

Even in Kyoto
when I hear the cuckoo
I long for Kyoto

Matsuo Bashō (1644–94)
Tr. David Cobb

Komagata Hall and Azuma Bridge. Hiroshige
Japanese woodcut. 1857

120

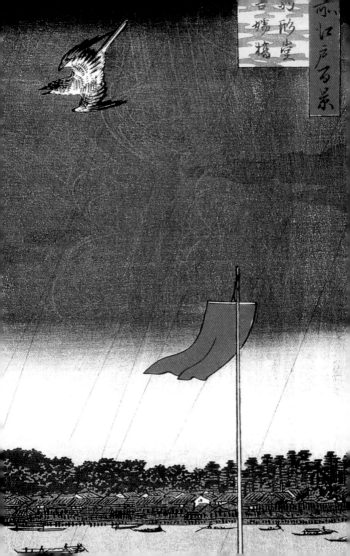

O blithe new-comer! I have heard,
I hear thee and rejoice:
O Cuckoo! shall I call thee Bird,
Or but a wandering Voice...

Thrice welcome, darling of the Spring!
Even yet thou art to me
No bird, but an invisible thing,
A voice, a mystery...

William Wordsworth,
from *To the Cuckoo*. 1807

Wordsworth was right to say the cuckoo is a mystery
since it was only very recently that ornithologists
discovered where the common cuckoo goes in winter.
Many attempts to ring the birds and track them
resulted in just a single success: a cuckoo ringed near
London on 23 June 1928 was shot down by a hunter
in Cameroon in West Africa on 30 January 1930
and the local pastor noticed the hunter's wife proudly
wearing the ring in her nose! He reported it to
the British Museum, which provided the key to further
research. Thanks to that pastor's perspicacity, we now
know that most cuckoos travel by night from Britain to
the forests of the Congo, crossing the Sahara without
resting, a flight of some fifty or sixty hours non-stop.

One thing we all know about the cuckoo is that it does not build its own nest or bring up its young, but removes an egg from the nest of another bird and lays its own egg in its place. Danish legend explains that the cuckoo is simply too busy answering mankind's questions, since the bird is often thought to tell fortunes, or at least provide guidance to farmers:

When the cuckoo comes to the bare thorn,
Sell your cow and buy your corn;
But when she comes to the full bit,
Sell your corn and buy your sheep.

In Russia, a cuckoo predicts how long you will live, while Bohemian tradition says the number of times it calls is the number of children you will have.

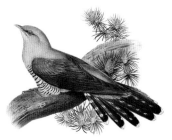

Cuckoo
John Gould
British
19th century

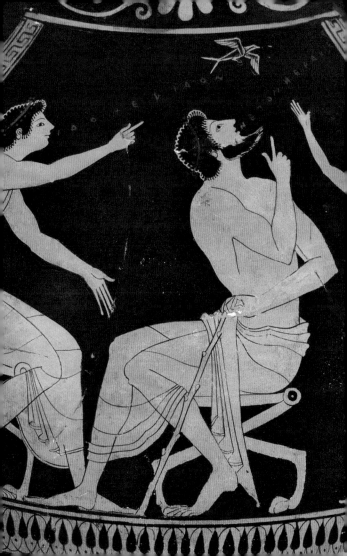

Swallow

A gulp of swallows. A swoop of swallows

The swallow darts and flits through the air (unlike the usually hidden cuckoo, the swallow's rival as the harbinger of spring), seeming to be dancing and swooping with glee and bringing joy to those who see it. Just such a scene is depicted on a famous Ancient Greek vase in the Hermitage museum, where the figures exclaim: 'Look! A swallow!' 'Yes indeed! Spring has come!' And if the inhabitants of the sunny south were so pleased to see the swallow, there can be no surprise that in colder climes the bird's arrival is greeted with such delight.

It is from Greece that we get the saying 'One swallow does not make a spring', first recorded by Aristotle (fourth century BCE), but reflected in one of Aesop's fables (sixth century BCE). A young man gambles away all his money and has only a cloak to keep him warm. When a swallow appears in the sky he immediately thinks that warm weather has arrived so he sells his coat to stake his money on one last bet. But again he loses and as he goes out into the world he discovers that the cold weather is back and the poor swallow has frozen to death.

125

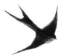

The robin and the wren
Are God Almighty's cock and hen
The swallow and the swift
Are God Almighty's gift.

Traditional Herefordshire saying

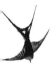

It was perhaps the association with spring that led to
the swallow being seen as the fire-bringer in Eastern
Europe and Asia: according to legend, all fire was
extinguished in a great flood and a swallow was sent
out to bring back fire from heaven. Some say that
the red on its feathers is a sign of its connection
with fire, others that the fork in its tail is where
the central feathers were burned when it stole its
precious trophy, while the rest of its feathers were
blackened by smoke …
For the Romans, swallows in a ship's rigging were
a bad omen. They were thought to foretell the death
of Cleopatra's lover, Mark Antony:

Swallows have built
In Cleopatra's sails their nests; the augurers
Say they know not, they cannot tell, look grimly,
And dare not speak their knowledge.

William Shakespeare,
from *Antony and Cleopatra*. 1607

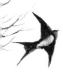

Swallows. Nikolay Ustinov. Russian. 1970s

127

Swallows are a delicacy in China, said to be the favourite dish of the dragons which are an important symbol of power and majesty in Chinese history and culture. Thus swallows were encouraged to nest in the eaves of houses and ledges were even provided for them. So numerous were these birds that Beijing was once known as 'capital city of swallows'. And traditional Chinese bird's nest soup is called 'swallow's nest' (*yànwō*), although the edible nest that is used is made of the solidified saliva of a swift rather than a swallow.

Not surprisingly, swallows are used in Chinese medicine, but early Western writers on medicine such as Pliny and Avicenna also wrote of the stone that grows in the belly of a young swallow in August which could be used to cure blindness or ward off epilepsy! Celandine, which Pliny said was used by swallows to give their young sight, is thus known as swallow's herb.

Swallow
Nikolay Ustinov
Russian. 1970s

Swallow
Chinese
painted silk
1760s–1770s

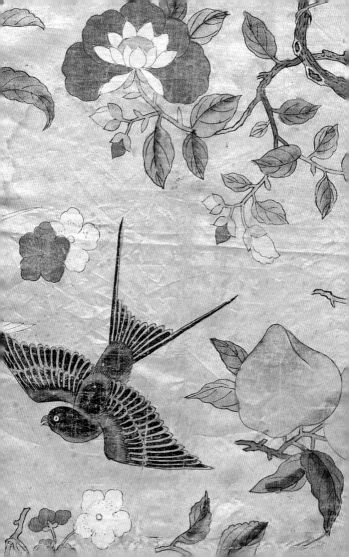

Surely the most curious legend about the swallow is where it goes in winter. Confused by the birds' sudden disappearance, literally overnight, many believed that each year the swallows died, only to be resurrected, that summer 'gives a sacred birth to the dead swallow', as seventeenth-century poet Thomas Carew put it. Even in the eighteenth century, more 'rational' naturalists could not explain where the bird went and followed Pliny in suggesting that at the start of cold weather the swallows huddled together deep in the mud of rivers and lakes. If Pliny described them as 'clinging together like bunches of grapes', Samuel Johnson in his famous dictionary defined the word 'conglobulate' as hanging together in clumps like swallows. Gilbert White described them joining claw to claw and beak to beak before sliding down the reeds into the mud...

Yatsumi Bridge. Hiroshige. Japanese woodcut. 1856

A Swallow
Has slipped through a fracture
 in the snow-sheet
Which is still our sky –
She flicks past, ahead of her name,
Twinkling away out over the lake.
Reaching this way and that way,
 with her scissors,
Snipping midges…

Ted Hughes, from *A Primer of Birds*. 1981

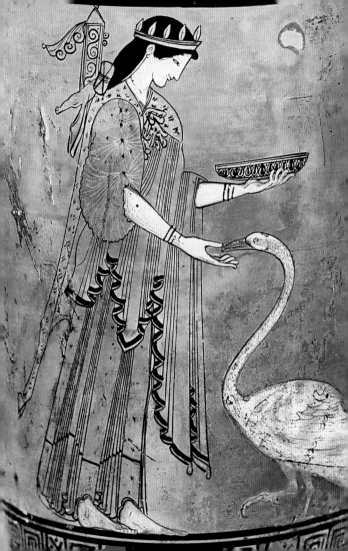

Swan

A wedge of swans. A bevy of swans. A drift of swans

Strong yet slender and supple, slow-gliding yet capable of striking at speed, the swan summons up associations with purity and perfection, beauty and fidelity. Not surprisingly, swans pulled the carriage of Greek goddess Aphrodite (the Roman Venus) and when the sun god Apollo flew to the land of the Hyperboreans for the winter he made the journey on the back of a swan. Apollo and his sister Artemis were born on an island surrounded by swans and swans flew round the island seven times to mark their birth. It was disguised as a handsome swan that Zeus, king of the Greek gods (Roman Jupiter), seduced Leda, a subject with great erotic potential that numerous artists have taken great delight in depicting over the ages. Their daughter Helen – who hatched from an egg – grew up to be the beautiful Helen of Troy, the 'face that launched a thousand ships' according to Christopher Marlowe. She was the innocent cause of the Trojan Wars, which in turn inspired the writing of two of the greatest works of Classical literature, Homer's *Iliad* and *Odyssey*, written in the late eighth century BCE.

*Artemis
and a Swan
The Pan Painter
Ancient Greek
white-ground vase
c. 490 BCE*

133

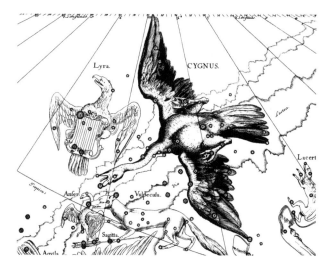

Cygnus is the name of a constellation, the origins of which also lie in Greek myth. According to one version, the name comes from Cycnus (Greek κύχνος – swan), a close friend of Phaeton, son of Helios (Greek god of the sun). Phaeton borrowed his father's sun chariot but was unable to control its fiery horses and they galloped away towards the earth, threatening the planet with destruction. To stop it in its path, Zeus destroyed it with a bolt of lightning. Phaeton was killed, falling into the river below.

Cygnus
Johannes Hevelius
Polish engraving
1690

Cycnus was inconsolable and the gods were so touched at his sorrow that they turned him into a swan. The first-century-BCE Roman poet Virgil offers us an even more romantic version, stating that Cycnus stayed by the water sorrowing and 'singing amongst the poplar leaves' until his hair turned white, and those white hairs then became feathers. Since Cycnus was a skilled musician, when he died Apollo – famous as a player of the lyre and god of music – rewarded him by placing him among the stars.

A swan made of felt, dating from the fifth to fourth
centuries BCE, is one of the most captivating objects
found in the Scythian tombs of the Altai Mountains
in southern Siberia. Although many more precious
items, particularly those made of gold, were stolen by
tomb robbers even as far back as Antiquity, most of
the objects considered necessary to nomadic Scythian

*Felt Swan
Ancient Altai
5th–4th century
BCE*

chieftains in the afterlife and buried alongside them
had no material value. Most fortuitously, the holes
made by those robbers let in water, which later froze,
preserving much of the organic material that lay
within. Felt was widely used by the nomadic peoples
of the Altai, for hats and stockings, saddlecloths and
carpets, and there can be no surprise that it was also
used to make a model of a bird symbolising the union
of life on earth, on water and in the air.

Swans had significance for many ancient peoples.
In a Mesolithic burial in Denmark, a newborn child
was laid upon a swan's wing in the earth. Petroglyphs –
images cut into rocks and stone faces – around Lake
Onega in northern Russia indicate that the prehistoric
inhabitants associated the bird with the heavens.
For Siberian peoples as well as some Turkic peoples
in Central Asia, swans were totems, sacred beings who
captured the essence of the tribe. In Hindu mythology,
swans have the same associations of purity and
divinity, but they are also seen as linked to knowledge
and creative power. Again we find the image of
a goddess riding a swan, in this instance Saraswati,
Hindu goddess of wisdom, nature and the arts. One
Anglo-Saxon riddle suggests that swans were flying
spirits, a metamorphosis of the souls of the dead,
while in medieval times bestiaries described swans as
'the merriest bird' (i.e. they were not birds of ill omen).

*Petroglyph Swans
Lake Onega,
Russia. 4th–3rd
century BCE*

137

With that, I saw two swans of goodly hue
Come softly swimming down along the Lee;
Two fairer birds I yet did never see.
The snow which doth the top of Pindus strew,
Did never whiter shew,
Nor Jove himself, when he a swan would be
For love of Leda, whiter did appear:
Yet Leda was they say as white as he,
Yet not so white as these, nor nothing near.
So purely white they were,
That even the gentle stream, the which them bare,
Seemed foul to them, and bade his billows spare
To wet their silken feathers, lest they might
Soil their fair plumes with water not so fair,
And mar their beauties bright,
That shone as heaven's light,
Against their bridal day, which was not long:
 Sweet Thames, run softly, till I end my song.

Edmund Spenser, from *Prothalamion*. 1596

Country Estate. Russian beadwork. Mid-18th century

138

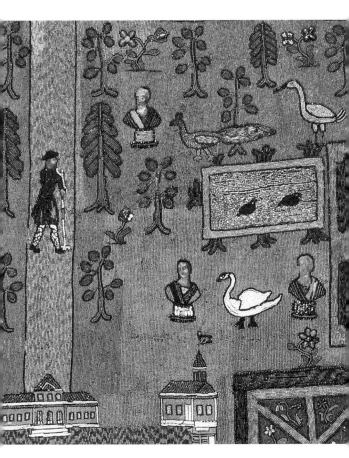

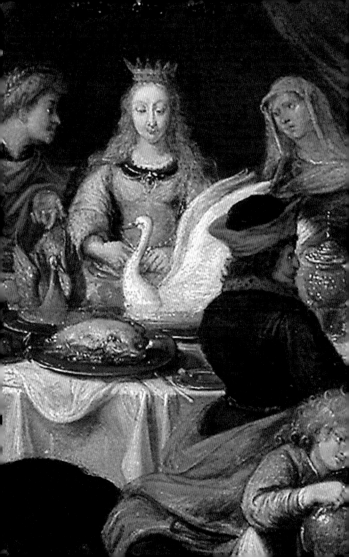

Swans have been considered the epitome of sumptuous dining – or at least, of conspicuous demonstration of the host's wealth and superiority – across Europe and Russia. Not for their taste, since most consider the meat to be tough and unappetising, but probably because of their size and beauty when dressed upon a plate. British royal records show that in 1251 Henry III celebrated Christmas with a banquet that served more than 350 swans, while from at least the sixteenth century onwards swan was first on the menu at the Russian court in Moscow when receiving foreign envoys.

The Marriage at Cana. Frans Francken the Younger. Flemish. 1630s

Swan. Italian micro-mosaic. Early 19th century

The silver Swan, who, living, had no Note,
When Death approached, unlocked her silent throat.
Leaning her breast upon the reedy shore,
Thus sang her first and last, and sang no more:
'Farewell, all joys! O Death, come close mine eyes!
More Geese than Swans now live, more Fools than Wise.'

Orland Gibbons (?), *The Silver Swan*. c. 1611

The concept of the 'swan song', that final outpouring
of talent and creativity before death, grew out of
the belief – often repeated from Classical Antiquity
through the medieval period – that as it dies the swan
bursts into glorious song. To those who know
the mute swans of Western Europe, that snort and
click rather than singing, this seems unlikely. Even
whooper and trumpeter swans, which do seem to
issue a series of notes as they die, can hardly be said
to sing beautifully. And yet the concept of the swan
song never dies. Perhaps because, all unconsciously,
we think – as Socrates declared – that as they sing
the swans foresee the joys of the afterlife.

142

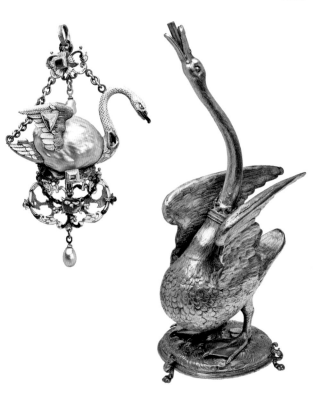

Pearl Swan Pendant. Dutch. c. 1590

Silver Swan. Evert Kettwick. German. 1635–43

Unusually, swans in folk and fairy tales can be either male or female. The Knight of the Swan – a hero who comes to rescue a princess in a boat pulled by swans – exists in French, German, English and other medieval traditions. But Germanic tradition also tells of a Swan Maiden, Swanhilde, who became the bride of Wayland the Smith. In the modern period, it was this feminine side of the swan that came to dominate, since it allowed for stories of a handsome hero rescuing a graceful white-skinned heroine. This was given poetic form in 1831 by Russian writer Alexander Pushkin, whose *Tale of Tsar Saltan, of His Son ... and of the Fair Swan Princess* (1831) later served as the basis for an opera by Nikolay Rimsky-Korsakov (1900).

Tailpiece to The Tale of Tsar Saltan Ivan Bilibin Russian. 1905

He looked round him, and, behold,
Saw a swan in evil plight;
Circling over it – a kite,
Talons spread, and bloodstained beak
Poised, prepared her death to wreak,
While the helpless bird was splashing,
With her wings the waters lashing.
But his shaft, with baneful note,
Struck the kite full in the throat.
Bleeding, in the sea it fell,
Screeching like a soul in hell.
He, with lowered bow, looked on
As, with beak and wings, the swan,
Dealing ruthless blow on blow
On the cruel kite, her foe,
Sped its death, till finally
Lifeless it sank in the sea.
Then, in Russian accents, she
Murmured plain as plain could be:
'O, tsarevich, champion peerless,
My deliverer so fearless …
'Tis no swan that you set free,
But a maiden charmed, you see … '

Alexander Pushkin,
from *A Tale of Tsar Saltan.* 1831
Tr. Louis Zelikoff (1978)

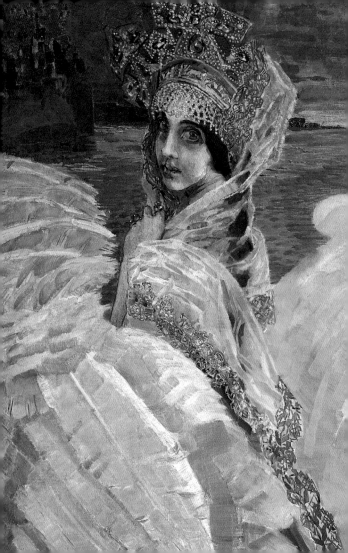

Thanks in no small part to the world of the ballet, today we have almost entirely forgotten the Knight of the Swan and remember only the Swan Princess. In 1875–76 Pyotr Tchaikovsky wrote *Swan Lake*, in which the heroine Odette is turned into a white swan, and in 1905 Mikhail Fokine created the choreography for *The Dying Swan* for the ballerina Anna Pavlova, to music by Camille Saint-Saëns.

For the premiere of Rimsky-Korsakov's opera *The Tale of Tsar Saltan*, sets and costumes were designed by Russian artist Mikhail Vrubel, whose wife sang the role of the Swan Princess.

The Swan Princess. Mikhail Vrubel. Russian. 1900

Swan. Russian beadwork. Mid-18th century

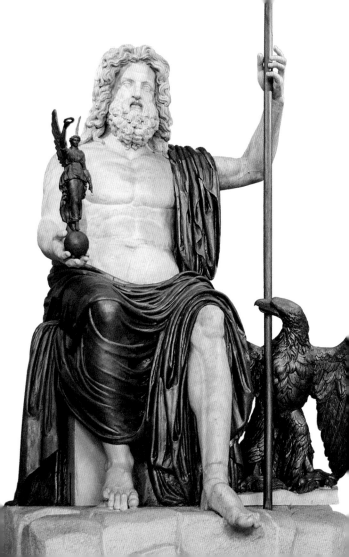

Eagle

An aerie of eagles. A convocation of eagles

Soaring high above the earth, 'at home inside the wind', eagles were thought to be able to look directly into the sun, as if into the face of god. They thus came to be associated with the sun gods of many religions. Outstretched eagle wings are attributes of the Sumerian god of war Ninurta (third millennium BCE) and the Assyrian god Ashur (third to first millennium BCE). In the Hindu religion, Garuda is the sun god and vehicle mount of Vishnu; Supreme Greek god Zeus (Roman Jupiter) has an eagle as his symbol, while Scandinavian god Odin turned into an eagle to seek the Mead of Poetry. In the Avesta (holy texts of Zoroastrianism) we see the eagle living on the Tree of Life. Eagles thus appear in art of many cultures from the fourth millennium BC, very often clasping a snake in its claws, symbolising light or heaven (the eagle) overcoming darkness (the snake).

When the snake and eagle meet,
* the world's foundation trembles.*

Percy Bysshe Shelley, from *The Revolt of Islam, Canto I.* 1818

Jupiter
Ancient Roman
sculpture
Late 1st century

149

The gods might appear on earth in the guise of
an eagle. Zeus, for instance, flew down to peck at
the liver of the giant Prometheus, who had dared steal
fire and bring it to mortals. Since Prometheus was
immortal, each day his liver was restored and each day
the eagle returned. It was as an eagle that Zeus stole
the handsome youth Ganymede, taking him up to
Mount Olympus to be his cup-bearer.

*Prometheus
and the Eagle
European intagli
17th century*

*Ganymede
Feeding the Eagl
Roman sculpture
1st century BCE
1st century CE*

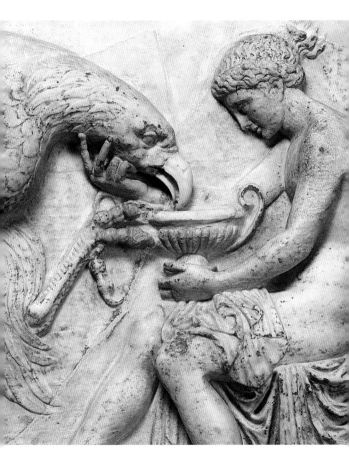

In the Christian tradition the eagle is the symbol of
St John the Evangelist. Sometimes John is shown not
as a man, but as a bird bearing a book or scroll, since
John was the author of the Gospel of St John in the
New Testament. By tradition he was also credited
with the last book in the Bible, the Book of Revelation,
commonly known as the Apocalypse. In the last years
of his life, it was said, he was exiled by the Roman
authorities to the Island of Patmos in the Aegean Sea,
where he wrote down this prophetic text. Why an eagle
for St John? Some commentators believe it is because
of the great soaring flights of John's thoughts, of the
visionary imagery he employs.

*Eagle: Symbol
of the Evangelist
John
Russian miniature
Early 15th century*

*The Evangelist
John on the Island
of Patmos
Flemish miniature
15th century*

152

Its association with the gods and with power meant that the eagle came to symbolise imperial might. In the Roman Empire each legion had a banner topped with an eagle that was carried into battle. The preservation of the banner and its eagle ensured the legion's victory and the lives of its soldiers, but its loss brought shame and punishment. Roman military symbolism also included an eagle with a hare in its talons, demonstrating both the pitiless nature of the Roman army and the weakness of the enemy in the face of that army. That image had deep historical roots: it appears on a Hittite relief of the second millennium BCE found at Alaca Höyük. In the early modern period the eagle continued to symbolise empire. The two-headed eagle had first appeared in the Ancient Near East but was revived in eleventh-century Byzantium, where the two heads symbolised that the Empire looked both East and West. This was particularly relevant when the two-headed eagle was adopted by the Holy Roman Empire after the fall of the Byzantine capital, Constantinople, in 1453. Today the eagle (both single and double-headed) survives in the state arms of many lands, of Germany, Austria and Russia, Poland and the United States of America.

*Eagle with a Hare
Italian cameo
13th century*

*Silver
Tetradrachma
323–284 BCE*

*Throne
Nicholas Clausen
British. 1731*

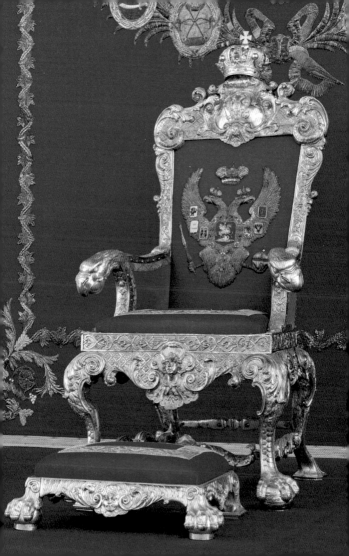

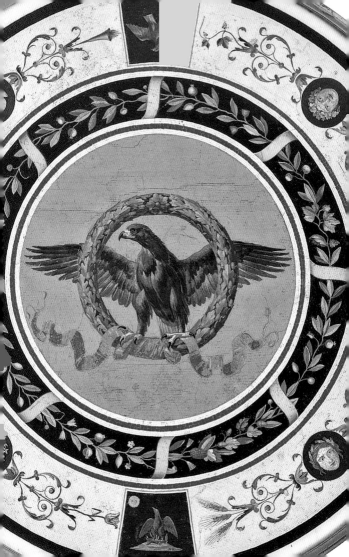

He clasps the crag with crooked hands;
Close to the sun in lonely lands,
Ring'd with the azure world, he stands.
The wrinkled sea beneath him crawls;
He watches from his mountain walls,
And like a thunderbolt he falls.

Alfred, Lord Tennyson, *The Eagle.* 1851

An eagle appearing on the eve of some great battle
or other event was taken as a sign of certain success.
Alexander the Great was said to have seen an eagle
when he founded the city of Alexandria in 332 BCE,
as was Emperor Constantine when he founded
Constantinople in 330 CE. When Russian Tsar Peter
the Great established his own new capital city,
St Petersburg, in 1703, he too was said to have seen
an eagle, ensuring that the city would flourish.
A century later, when Russian troops faced Napoleon's
army at the Battle of Borodino, an eagle supposedly
circled the head of the Russian commander,
Mikhail Kutuzov. Although the Battle of Borodino
was not a victory for the Russian army, Napoleon was
eventually to be defeated thanks largely to Kutuzov's
strategic withdrawal from Moscow.

Mosaic table top. Workshop of Francesco Belloni. French. c. 1803

H·ET·P·

Candelabrum
Workshop
of Pierre-Philippe
Thomire
French. 1st quarter
of the 19th century

Mantle Clock
French. 1798

Napoleon's taste for Roman symbols of empire, not least of them the eagle, led to the appearance of a new artistic trend that came to be known as the Empire Style. In the early nineteenth century military trophies, Roman banners and eagles with wings outstretched appeared on clocks and lamps, vases and urns, even on embroidered wall panels.

Eagles are not merely divine. They have played a central role in the daily life of many peoples. Hunters across the world – perhaps even since Palaeolothic times – used feathers from an eagle's tail to flitch their arrows in the hope that it would imbue them with some of the bird's qualities. The indigeneous peoples of North America attached feathers to headdresses and other objects with similar purpose. We talk of someone with keen eyesight, who lets nothing past, as being 'eagle-eyed', a quality vital to the successful hunter in any age.

To small livestock farmers, however, the eagle has been seen as a pest. In Scotland, for instance, each householder in a village would have to pay a hen to a hunter who caught an eagle. The long wings of a sea eagle (the wingspan of a white-tailed eagle, for instance, can be up to 2.2 m) were then used as a broom. This may have been more than mere practicality: by allocating such a prosaic function to the wing, the householder seemingly demonstrated 'victory' over the vanquished bird.

Since the eagle is the bird of the god Zeus, wrote Pliny, it is the only bird never to have been struck by a thunderbolt. The association between the eagle and storms and lightning explains why in some southern lands it was thought that burying the right wing of an eagle in vineyards would ward off hailstorms.

Pipe
Indigenous people
of the Great Plains
19th century

Eagle Warrior
Pendant Bell
Central America
15th–16th century

Other tales tell of children being carried off by eagles, and in the early twentieth century one Norwegian woman claimed to have survived such an episode! This is surely the stuff of legend, of tales of Ganymede being carried off by Zeus and Japanese Shamanic stories of children stolen by eagles. Even the largest eagles are not capable of bearing such weight and anything heavier than a few kilograms is torn apart and eaten on the spot.

Peafowl

An ostentation of peacocks. A pride of peacocks

With tail feathers up to 1.6 m long, the Indian peafowl (*pavo cristatus*) is often called by the name of the male, the peacock. Slow and self-important, the bird is known in Spanish as the *pavo reale*, from which we get the stately dance called the pavane.

In its native India the peacock plays an important role as the vehicle mount of Kartikeya, god of war, and the name of Mahamayuri Vidyarajni, a Buddhist deity, means 'Great Peacock Wisdom Queen': she is often seen riding a peacock with wings and tail spread. Naturally, when the bird reached Europe – probably only around the sixth century BCE – it rapidly came to be associated with the consort of Zeus, Hera (Roman Juno), and was often depicted harnessed in pairs drawing her chariot.

In contrast with such positive associations, in Europe the peacock rapidly came to be seen as the very embodiment of human vanity – this is recorded in the first century BCE in the writings of the poet Horace. The phrase 'proud as a peacock' – or sometimes 'as vain as a peacock' – is current in many different languages.

Krishna and Radha Exchanging Clothes Indian miniature Mid-18th century

163

March comes in with an adder's head
and goes out with a peacock's tail.

English proverb

Peacocks only became a relatively familiar sight in
royal parks and gardens in Europe after the fourteenth
century. It was the expansion of the British Empire
through India in the eighteenth century that did so
much to make them an intrinsic part of aristocratic
culture. What was a landscaped park without
a peacock or two to enliven it?
Across Europe nobles and monarchs stocked their
grounds with these exotic birds. In 1793, by order
of Frederick William II of Prussia, peacocks were
installed on the royal estate on an island in the River
Havel in Berlin. His son Frederick William III
expanded the flock and it was there, on what had
become known as Peacock Island, that Princess
Charlotte – who later married Emperor Nicholas I
and became Empress of Russia – loved to walk. This
fairytale island is now a protected area, still occupied
by peacocks and ringing with their mournful cries.

Peacock Island. Peter Ludwig Lütke. German. 1821

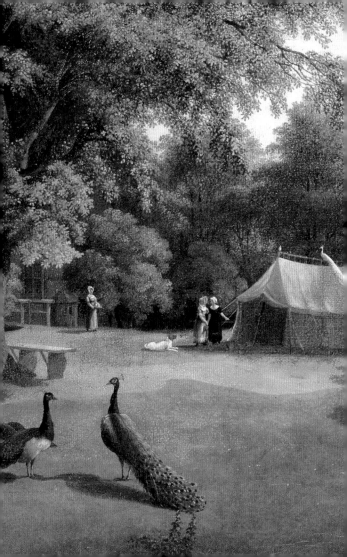

In the East the 'eye' in the peacock's tail feather is identified with the eye of god and the feathers are much prized. In Manchuria, a peacock feather was presented as a mark of the emperor's favour. But for all their beauty, in Europe the tail feathers of the male peafowl were thought to bring bad luck, the 'eye' not that of god but of some evil magic power. Ostrich feathers were thus preferred for fans and headdresses, which did something to save the poor peafowl from the fate that met so many other birds, killed for the feathers that formed an important element of female fashions. They were also saved by the fact that it was universally agreed by writers from Pliny onwards that even if hung for weeks the meat of the peacock was tough and more or less inedible. That did not entirely stop the presentation of peacocks on the banquetting table, though more as a matter of prestige and for the sake of effect than as a delicacy.

You are lost in admiration when he spreads his feathers that glow as it were with jewels, and can you consign him, cruel man, to the unfeeling cook?

Martial (c. 40 – c. 103), *Epigrams, XIII: LXX.* Tr. Anon (1897)

Peacock Brooch Russian. 1880s

Medieval miniature Flemish 15th century

The passion for automata – machines imitating human or animal actions – reached new heights in the eighteenth century with the development of sophisticated clockwork mechanisms. It became possible to make metal figures function smoothly, with nuances of movement that were amazingly lifelike. Empress Catherine II's great rival,

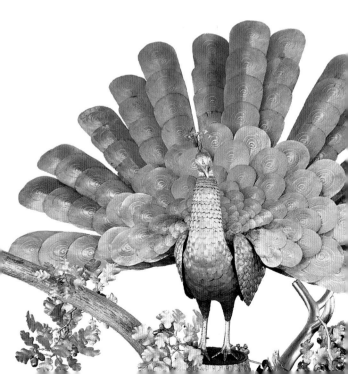

Frederick II of Prussia, was said to have been obsessed by automata and it is no surprise that Catherine wanted an example for herself. So it was that in 1777 Prince Grigory Potemkin ordered a monumental automaton for her from the London inventor and goldsmith James Cox, whose museum on Spring Gardens in London drew crowds with its variety of exotic moving figures.

Cox's peacock – which cost Catherine the huge sum of £1,800 – is not the only bird in the composition. First an owl in a cage of bells taps its foot and twists its head, then the glorious golden peacock stretches up and twists its neck, throwing back its head, before raising its tail and spinning round to ensure we see all its glories. Then a cockerel crows, perhaps drawing attention to the peacock's vanity.

The clock was sent to Russia in parts – and without instructions – so a celebrated Russian inventor, Ivan Kulibin, had to be brought in to put it together (and make replacements for missing bits). Today it serves as a monument to two great mechanics of the eighteenth century, one British, one Russian.

Peacock Clock. James Cox, Friedrich Jury. British. 1766–72

A peacock met, in silvan dale,
That tuneful bird, the nightingale.
To praise one's self is not so wise,
Though many do it to the skies.
Says Pea, 'thy talent much assumes,
But what are songs to matchless plumes?'

The bird of note with less of pride,
In softest melody replied:
'Music the soul can soothe and feast,
And equals gaudy plumes at least.'

The sober night advancing mute,
Came on to settle this dispute.
At eve the peacock's bright display
Was lost: all birds by night are grey;
While music floating o'er the farms
Acquired by night uncommon charms.

Intrinsic talents worth can raise
Above mere beauty's brightest blaze:
Beauty, at times, some men adore,
Talents, all men forevermore.

'Armoricus',
The Peacock and the Nightingale. 1817

So upset was the peacock that the small and insigificant nightingale was so admired, that he asked the goddess Juno to replace his own harsh cry with a beautiful voice. She tried to console him, describing his glorious feathers, but still he was not content. At which Juno became cross and said: 'Each bird has been assigned some advantage by the fates: to thee has been given beauty, to the eagle – strength; to the nightingale they gave song; to the raven favourable auguries, to the crow unfavourable. Each must be content with what he has.'

Vainglory: As regards this vice we read of the peacock being more subject to it than any other creature, because it is always contemplating the beauty of its tail, spreading it out in the form of a wheel and attracting to itself by its cries the attention of the surrounding animals.

Peacock
Joseph Smit
after Joseph Wolf
Dutch lithograph
1872

Leonardo da Vinci (1452–1519), from *Bestiary*
Tr. Edward MacCurdy (1939)

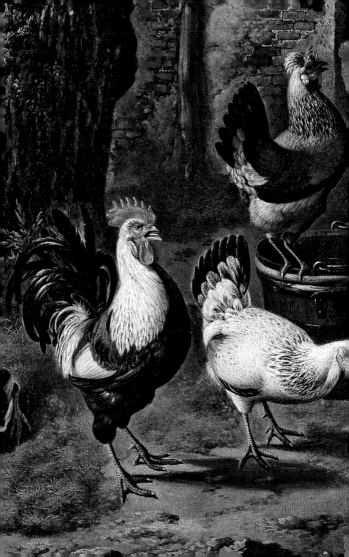

Chicken

A flock of chickens. A cluck of chickens. A peep of chicks

We might think of chickens as being something just too ordinary for words: they have become such an important part of the food industry that they are bred in their millions and are today the most numerous of any bird on the planet. Estimates vary, but there are something in excess of 19 billion chickens, kept for their eggs and their meat, but also for their feathers. And we should never forget that the chicken is a descendant of the red junglefowl – related to peacocks and pheasants – so it comes as no surprise that there are some very handsome decorative breeds. If the hens seem nervous (which is why children cry 'Chicken!' when someone hesitates to do something daring), cockerels strut proudly, raising their voices and dominating their territory, attacking any other cockerel who dares encroach upon it – the source of another phrase: 'Cock of the walk.' Since, the cockerel (American: rooster), master of all he surveys, is usually far handsomer and more gaily coloured than his wives, it is he who appears most often in art of all ages.

Poultry Yard
Dirk Wijntrack
Dutch. 1643

Some of the earliest depictions of chickens – carved in ivory – are found in Assyria and date from around 1300 BCE. In the fifth century BCE the rooster was described by Aristophanes as 'the Persian bird', but its origins seem to be somewhere in China or even Thailand.

Associated with the sun, because its call heralds the dawning of the day, the cockerel has been linked with sun gods and the battle against darkness.

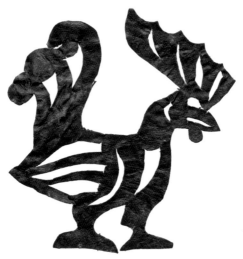

Leather Cockerel
Ancient Altai
5th century
BCE

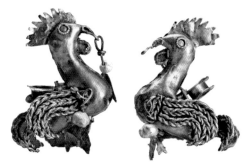

The cockerel is the sacred bird of Ahura Mazda of the Zoroastrian religion that emerged in Persia in the second millennium BCE, and Greek gods including Athene and Hermes were served by cockerels. Cockerels were sacrificed to Asclepius, Greek god of medicine, in thanks for recovery from illness, which is why the last words of the philosopher Socrates – an instruction to pay Asclepius a cockerel – has given rise to question. Socrates was perhaps thanking the god for healing him of the sickness of life.

The Romans used both cocks and hens for fortune telling and the blood of the bird has been a frequent element of magic across the world, from Greece and Rome to the witch-doctors and voodoo of Africa, Afro-Caribbean countries and Latin America.

Cockerels
Gold, pearls
Archaeological
find

Marking the end of night and darkness, the crowing of the cock in the Christian religion symbolises resurrection and the dispelling of all ghosts, including that of Hamlet's dead father:

It faded on the crowing of the cock.
Some say that ever 'gainst that season comes
Wherein our Saviour's birth is celebrated,
This bird of dawning singeth all night long;
And, they say, no spirit dare stir abroad,
The nights are wholesome, then no planets strike,
No fairy tales, nor witch hath power to charm,
So hallow'd and so gracious is that time.

William Shakespeare, from *Hamlet*. c. 1600

And when the Apostle Peter disowned Christ after his arrest, as Jesus had himself prophesied, it was the crowing of the cock that made him realise his error, such that he wept and repented. Thus the cockerel has come to stand for the awakening of the soul in response to the call of God.

Peter's Denial of Christ. Chapel of Notre-Dame des Fontaines, La Brigue. Giovanni Canavesio. Italian fresco. 15th century

For lovers of riotous living who lie abed in the morning, the cockerel's cry is not always welcome.

Thou cursed cock, with thy perpetual noise,
May'st thou be capon made, and lose thy voice,
Or on a dunghill may'st thou spend thy blood,
And vermin prey upon thy craven brood;
May rivals tread thy hens before thy face,
Then with redoubled courage give thee chase;
May'st thou be punish'd for St. Peter's crime,
And on Shrove Tuesday, perish in thy prime;
May thy bruis'd carcass be some beggar's feast,
Thou first and worst disturber of man's rest.

Sir Charles Sedley (1639–1701),
On a Cock at Rochester

What does a cockerel cry?

Chinese – *goh-geh-goh-goh*
English – *cock-a-doodle-do*
Finnish – *kukkokiekuu*
Russian – *ku-ka-re-ku*
Spanish – *kikiriki*
Swahili – *koromiko*

Cockerel
Melchior
d'Hondecoeter
Dutch. 1686

In many cultures it is the task of the cockerel to summon the day, to call up the sun and bring new life. Such an episode is found in the *Records of Ancient Matters* (*Kojiki*), Japan's oldest chronicle, written in around 712. Amaterasu the sun goddess, most sacred of all Shintō, the storm god, deities, was insulted by the actions of her brother Susanō and hid away in the Heavenly Cave. The whole world was sunk in darkness and evil spread. Amaterasu refused to come forth, despite all pleading. Then the other gods urged the cockerels to cry and declare the coming of dawn, so that the forces of darkness would not take over the world. When Amaterasu emerged, the gods blocked up the entrance to the cave to prevent her hiding again.

Cockerels are still kept at Shinto shrines dedicated to Amaterasu: their task is to call the goddess to the temple each morning. With its raucous cry of *Ko-ke-kokkoh!*, the cockerel is for the Japanese a symbol of light, but also of courage.

Images of cockerels were used to adorn all kinds of objects. Temple censers and incense burners might take the shape of a cockerel, and chickens – both cock and hen – beneath a flowering tree often appeared on Japanese lacquered objects such as the cases known as *inrō*, in kimono embroideries or painted on silk. Cockerels also appear on Japanese netsuke (ivory toggles used to suspend containers on a silk cord from a man's sash). One unusual but popular form in the late eighteenth and early nineteenth centuries shows a Dutchman clasping a cockerel to his chest. The Dutch were the only Europeans allowed to trade in Japanese waters and the cockerel seems to have been associated with them because of their passion for cockfighting.

In 1952 the Onagadori or Japanese long-tailed chicken was declared a National Natural Treasure, yet despite the significance of chickens and the number of cockerels in Japanese art, they rarely appear in traditional haiku, the three-line poems so often devoted to nature – particularly birds – and man's relationship with the natural world.

Inrō Case
Japanese
Early
19th century

The only bird among the signs of the Chinese zodiac, the cockerel is the tenth in the cycle of twelve: rat, ox, tiger, rabbit, dragon, snake, horse, goat, monkey, cockerel, dog and pig. According to a popular tale, their order was determined by a race organised by the Jade Emperor, one of the names for the 'first god' of Chinese mythology and religion.

In China the crowing of the cockerel is thought to have the power of dispelling demons. So it is that on the eve of Chinese new year images of cockerels are hung out on gates, doors and windows to protect against evil in the coming days.

The bird is also seen as encapsulating five cardinal virtues of the ethical code set down by Confucius in the sixth to fifth centuries BCE:

Civic virtue – bearing itself proudly.

Martial virtue – because of its spurs.

Courage – never afraid, it spies out the enemy and attacks.

Benevolence – it shares grain with its fellows.

Reliability – every morn, without fail, it crows.

Cockfight. Chinese enamel. 18th century

On pp. 184–85
Cockfight. Ancient Greek black-figure vase. c. 520 BCE

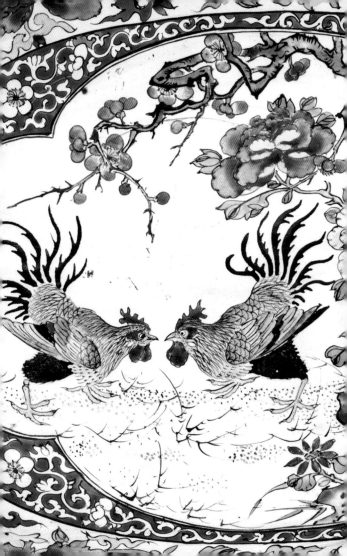

The multiple uses of the chicken have been its downfall: the hen's eggs and her flesh taste good, while the cockerel became the victim of man's obsession with cockfighting, exploiting the natural aggression of one male bird for another. Fighting cocks were known in Persia, India and China and the Persians introduced them to Babylon. The Greeks took up the 'sport' after their invasion of Persia in the sixth to fifth centuries BCE and even built

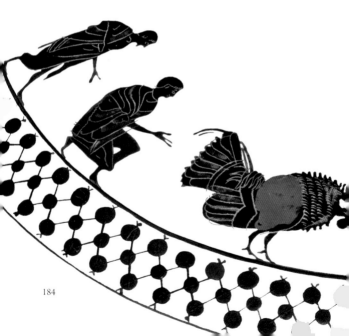

special amphitheatres for cockfights. Though the Romans preferred gladiator fights to cockfights, by the late medieval period cockfighting was a popular pastime across Europe.

In Britain, cockfighting became known as 'the royal diversion', because it was one of the favourite pastimes of King Henry VIII. In around 1530 he had a royal cockpit built alongside his official residence, the Palace of Whitehall.

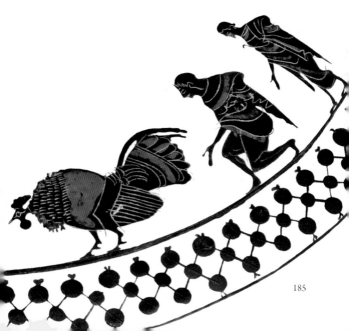

In 1614 cocking was listed in Gervase Markham's book on *The Pleasures of Princes, or Good Mens' Recreations*, which specifically described how to choose, train, breed and feed a fighting cock. Over time its popularity spread and it eventually drew men from all classes and all walks of life. In the eighteenth and early nineteenth centuries cockfights were an accepted, even respected, part of male societal interaction in Western Europe and North America. Birds were trained and exercised when not fighting and the staff of a wealthy individual often included a 'feeder' solely to care for his gamecocks.

To add piquancy to the fight, in the eighteenth century the cocks were given long, sharp silver spurs that could kill or maim with one strike. Starting out with sixteen pairs of birds (or more), the winner was the last cockerel standing. Inevitably, cockfights increasingly came to be associated with gambling, often excessive, and with drunkenness. It was as much to deal with those social problems as with cruelty to animals that many countries banned the 'sport' in the mid-nineteenth century.

Today cockfighting is still permitted in some parts of the Americas and Asia, even in some regions of Europe where it is considered to be part of the national culture. But its most notable legacy is the word cockpit, which comes from the sunken

Chicken
Russian tile
Early
18th century

186

enclosure or pit in which the birds fought. Though cockfighting is largely a thing of the past, the cockpit lingers on as the name given to the place in a plane or a boat where the pilot sits.

Cockerels, head raised to crow loudly, often appear as weathervanes on the tops of churches and public buildings, on barns and houses. This is due partly to their association with wakefulness, ready to give cry at the appearance of some threat, but also to the connection with St Peter. For it was the crowing of the cock that brought Peter to repent, to recognise his own faith. Some time around 600 CE, Pope Gregory I declared that Peter's cockerel should symbolise Christianity overall and the summons to church. In the ninth century Pope Nicholas decreed that a cockerel appear on the outside of all churches to carry this message.

*Cockerel
Cathedral
of St Vitus
in Prague
Czech*

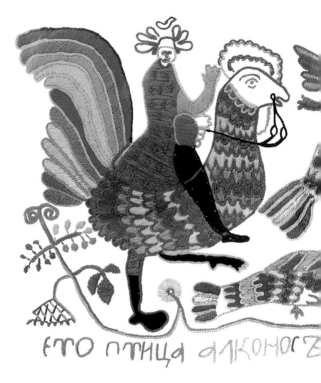

Inside the houses of ordinary people, the cockerel was the alarm clock that woke them in the morning, a protection against external threats, and his hens were a source of food. Playing a central role in

188

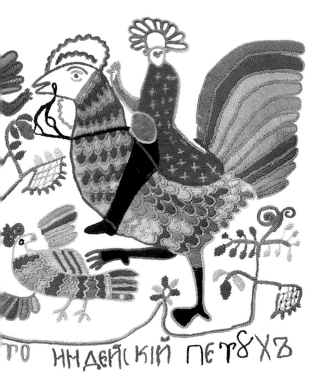

ГО ИНДЄЙСКIЙ ПЄТ8ХЪ

Alkonost and
Cockerel Riders
Russian
embroidery
19th century

everyday life, cockerels appeared in folk art around the world, painted on shutters, wooden trunks and boxes, woven into all kinds of textiles and embroidered on towels, aprons, curtains and tablecloths.

189

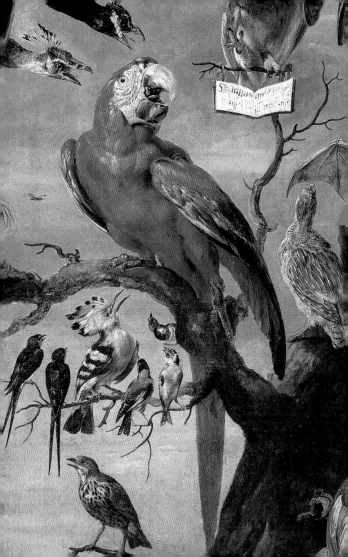

Parrot

A pandemonium of parrots. A prattle of parrots

From the green-winged macaw to the grey parrot and the budgerigar (also known as the parakeet), parrots come, it seems, in all shapes and sizes, and certainly in all colours. There are more than three hundred varieties, some no more than 10 cm long including their tail. At nearly a metre long the largest is the green-winged macaw (mainly red, despite its name). Native to the warm tropical and sub-tropical forests of Asia, Africa, the Americas, Australia and New Zealand, parrots do not seem to have been known in Europe until around the fourth century BCE, when they were still extremely rare. It was only during the late Roman Republic that they came to be a popular pet of the wealthy. From the late fifteenth century, after the discovery of America, tropical birds were imported to Europe for royal aviaries, both for their colour and their ability to talk. Amazon parrots and grey parrots are among the most skilled talkers, with the smaller parakeets and budgerigars capable of quite extensive vocabularies, although there is no agreement as to whether the birds have any understanding of the meaning of what they say.

A Concert of Birds
Frans Snyders
Flemish. 1630s

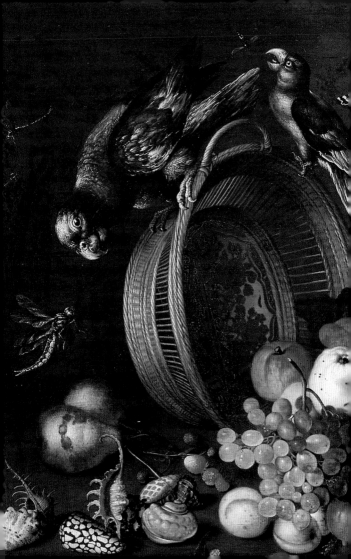

From the seventeenth century parrots started to
appear quite regularly – along with monkeys – in still
lifes and portraits, where they served as symbols of
the sitter's wealth, since these exotic birds and beasts
were fiendishly expensive. Luckily by this time people
had stopped believing Pliny, who stated in the first
century that in order to teach the bird to speak 'it must
be beaten on the head with an iron rod; its head is
so hard that it will not feel lesser blows'.

*Still Life with Fruit and Flowers. Balthasar van der Ast
Dutch. c.1625*

The Parrot Cage. Jan Steen. Dutch. 1660s

Our parrot, prince of mimics, is no more.
Throng to his burial, pious tribes of air,
With rigid claw your tender faces tear!
Your ruffled plumes, like mourners' tresses, rend,
And all your notes, like funeral trumpets, blend!
Mourn all that cleave the liquid skies; but chief,
Beloved turtle, lead the general grief,—
Through long harmonious days the parrot's friend,
In mutual faith still loyal to the end!
What boots that faith? those splendid
 hues and strange?
That voice so skilled its various notes to change?
What to have won my gentle lady's grace?
Thou diest, hapless glory of thy race.
Red joined with saffron in thy beak was seen,
And green thy wings beyond the emerald's sheen;
Nor ever lived on earth a wiser bird,
With lisping voice to answer all he heard.
Our parrot, prince of mimics, is no more.

Ovid (43 BCE – 18 CE),
from *On the Death of Corinna's Parrot*
Tr. Alfred John Church (1876)

Parrot
Italian mosaic
18th century

Popinjay – an archaic word for a parrot, from the French *papegay*. It came to be used to describe someone who is conceited or over-talkative, but also, presumably because of parrots' colourful feathers, someone who is foppish or who dresses in an extravagant manner.

Parrots came to Muscovy in 1490, when a colourful bird was among the many gifts presented to Russian Tsar Ivan III by an ambassador from Holy Roman Emperor Maximilian I. We know this because it appears in a list of all the things brought to Russia by foreign merchants and diplomats for sovereigns and members of their family. Meticulously recording the number of birds presented, their sex and colour, the list – which is now in the archives in Moscow – also names the giver or seller and describes the cage, stating whether it was of simple wire or gilded wood. Although parrots are not native to Russia, a fossilised parrot bone some sixteen million years old was discovered in 2016 near Lake Baikal in Siberia, suggesting that these birds once spread into Eurasia.

Girl with a Parrot. Russian. Mid-18th century

Parrot. Persian miniature. 18th century

Parrots played a somewhat more fundamental role
in the East. For Hindus, the parakeet is the vehicle
of Kamadeva (god of human love) and his consort
Rati. Son of lord Vishnu and the goddess Lakshmi,
Kamadeva serves a function similar to Cupid in
Classical mythology, bringing desire and passion to
mankind. But he is also seen as the source of poetic
inspiration and the parrot has connotations of
wisdom. In India and Persia (Iran) the parrot has been
seen as a storyteller and in a twelfth-century Sanskrit
text known as *Seventy Tales of the Parrot*, adapted
in Persia in the fourteenth century, a parrot tells his
owner's wife long stories to entertain her and prevent
her going out to meet a lover in her husband's absence.
His ribald tales keep her enthralled – and faithful – for
seventy days, until her husband returns.

Parrot
French enamel
12th century

One of the most famous of all parrots was that belonging to Long John Silver in the novel *Treasure Island*. When we think of pirates today we immediately imagine them with a wooden leg (like Silver) and a colourful parrot on their shoulder.

All the crew respected and even obeyed Long John Silver. 'Come away, Hawkins,' he would say, 'come and have a yarn with John. Sit you down and hear the news. Here's Cap'n Flint – I calls my parrot Cap'n Flint after the famous buccaneer – here's Cap'n Flint predicting success to our voyage. Wasn't you, cap'n?'
And the parrot would say, with great rapidity, 'Pieces of eight! pieces of eight! pieces of eight!' till you wondered that it was not out of breath, or till John threw his handkerchief over the cage.
'Ah, she's a handsome craft, she is,' the cook would say, and give her sugar from his pocket, and then the bird would peck at the bars and swear straight on, passing belief for wickedness.

Robert Louis Stevenson, from *Treasure Island*. 1882

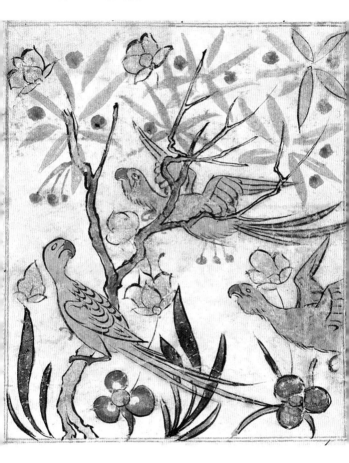

Until relatively recently the only place one could be sure of seeing a parakeet in Europe was in a cage, although as early as the mid-nineteenth century there were sightings of escaped birds. In the UK parakeets were seen in Norfolk in 1855. In Dulwich just outside London in 1893. Since the 1950s the number has increased rapidly and in 2018 it was recorded that there were about 10,000 ring-necked parakeets (also known as rose-ringed parakeets) living in France, 15,000 in the Netherlands and more than double that in the United Kingdom. In some large cities – in West London, in the Park in central Brussels (the one city has more than 12,000 parakeets), in the suburbs of Paris – their screeching and squawking often drowns out other birdsong and where once people were pleased to see these green interlopers, there is talk of culling in order to protect native bird species. Everyone has their own theory as to where the parakeets came from. Those in Paris were said to have escaped from planes that landed in the 1970s and 1990s. In London, legend has it that a pair was released in the 1960s by rock musician Jimi Hendrix. Most of the parakeets in the Brussels region are descended from 40 birds released from the Meli amusement park in 1974. Whatever their source, there are now more than 100,000 ring-necked parakeets living wild in Europe.

Miniature from Ibn Bakhtīshū's Book of the Uses of Beasts Persian Late 13th century

However romantic it may be to think of Long John Silver's parrot sitting on his shoulder, parrots are best trained – like birds of prey – to sit on the hand. For they are zygodactyls, which means that of the four toes they have on each foot two point forward and two project backwards.

But taking on a parrot as a pet is a huge responsibility: Amazon parrots live from 25 to 50 years, sometimes much longer, and cockatoos are expected to enjoy a lifespan of 50 to 70 years. Even budgerigars (the most popular of the parrots to be kept as pets) live anything from 15 to 20 years. And in all that time a parrot never becomes domesticated: unlike cats and dogs and despite its apparently sociable character, it remains wild at heart, with no true loyalty to any human.

Parrot
Italian mosaic
19th century

Children
with a Parrot
Christina
Robertson
British. 1850

Owl

A stare of owls. A wisdom of owls. A parliament of owls

Sacred bird of Athene, Greek goddess of wisdom, patron of the sciences, arts and crafts (her Roman equivalent was Minerva), the owl itself soon came to be perceived as the epitome of wisdom. Athene's owl was a little owl, whose Latin name not surprisingly is *Athene noctua*.

But because of their nocturnal habits owls also came to be associated with the Greek goddess of the night, Nyx. This, combined with the eerie night-time hooting of the tawny owl (by no means all owls hoot), gave the bird a negative reputation, a connection with dark forces. Among many peoples – the Egyptians, Celts, Aztecs, Maya and Chinese – owls have been seen as harbingers of doom, while in Europe they are frequently associated with witchcraft.

Owls are a sign of desolation in the Old Testament of the Jewish and Christian religions, a mark of the absence of human life:

Owl
Ancient Greek
red-figure vase
6th–5th century
BCE

Therefore the wild beasts of the desert with the wild beasts of the islands shall dwell there, and the owls shall dwell therein; and it shall be no more inhabited for ever…

205

CMAZEROLLE. 1876.

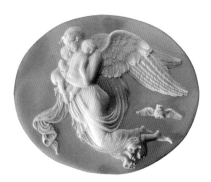

Sources from Pliny through to medieval bestiaries
(setting out the qualities and symbolism of different
animals) are united in describing owls as dirty and
evil. But from the late nineteenth century onwards
there was a revolution in attitudes and even while
retaining an association with night, owls came to play
a benign role in children's books and poetry.
In A. A. Milne's novels about Winnie the Pooh, Owl
is a bumbling but benign friend, while J. K. Rowling's
Harry Potter novels made owls into a must-have good
wizard accessory.

The Wicked Witch at the Christening. French tapestry. 1876–89

Allegory of Night. After Bertel Thorvaldsen. Cameo. 1830s–1840s

Pussy said to the Owl, 'You elegant fowl!
 How charmingly sweet you sing!
O let us be married! too long we have tarried:
 But what shall we do for a ring?'
They sailed away, for a year and a day,
 To the land where the Bong-Tree grows
And there in a wood a Piggy-wig stood
 With a ring at the end of his nose,
 His nose,
 His nose,
 With a ring at the end of his nose.

'Dear Pig, are you willing to sell for one shilling
 Your ring?' Said the Piggy, 'I will.'
So they took it away, and were married next day
 By the Turkey who lives on the hill.
They dined on mince, and slices of quince,
 Which they ate with a runcible spoon;
And hand in hand, on the edge of the sand,
 They danced by the light of the moon,
 The moon,
 The moon,
 They danced by the light of the moon.

Edward Lear, from *The Owl and the Pussycat*. 1871

*Silver
Tetradrachma
with an Owl
Ancient Greek
5th century BCE*

*Owl in a Gothic
Window
Caspar David
Friedrich
German. c. 1836*

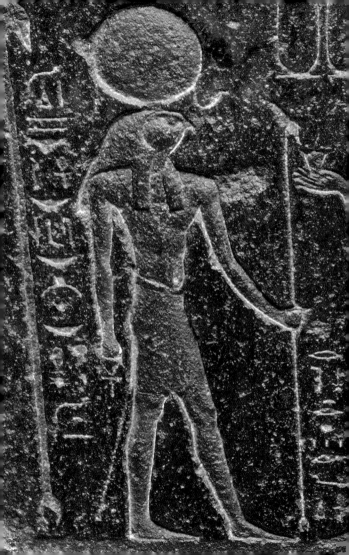

Falcon

A cast of falcons. A ringing of falcons. A bazaar of falcons

It was in Ancient Egypt that the falcon achieved its highest status. For the falcon – the bird we know today as the peregrine falcon – was the symbol of two gods, Horus and Ra. Both were shown with falcon heads, but Horus wore a crown that symbolised his dominance over Egypt while on the head of Ra, the sun god, we see the disc of the sun wrapped within a cobra. Falcons appear on Egyptian sarcophagi, on stone stele, as statuettes and amulets that were worn to protect against evil spirits, and on papyrus documents. Even the chance killing of this sacred bird was punishable with death.

Falcons were first trained by humans to use in hunting perhaps as early as the second millennium BCE, probably in the Ancient Near East. Falconry went on to become particularly widespread among the nomadic peoples of Asia and the Arabian lands, as well as in North Africa. Exactly how the practice spread is unclear, although descriptions and images occur in China and Japan, in Early Christian Rome and amongst the Goths. By the ninth century falconry was a popular noble pastime in Europe.

Ra
Ancient Egyptian
clepsydra
(water clock)
4th century BCE

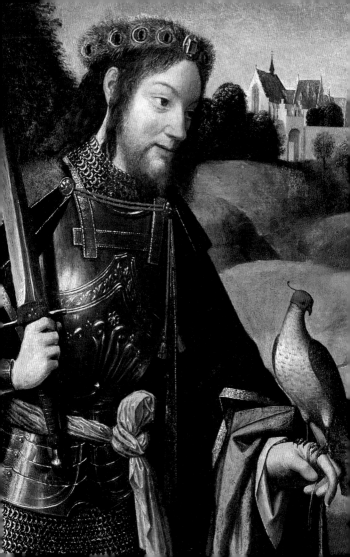

One of the most famous medieval falconers was Frederick II von Hohenstaufen (1194–1250), Holy Roman Emperor, who had nearly fifty falconers at court. Towards the end of his life he wrote his own extensive book on hunting with birds of prey, *The Art of Falconry*. So widespread was hunting with birds that falcons were precious gifts worthy of monarchs. Thus, when the King of Norway wanted to find a suitable gift for Henry III of England in 1236 he chose ten grey and three white gyrfalcons. In 1385 the Castilian statesman Pero López de Ayala wrote that the falcon was 'the most noble and best of the raptors, lord and prince of the birds of prey'. And when Holy Roman Emperor Charles V granted the archipelago of Malta to the Knights of the Hospital of St John of Jerusalem in 1530, the annual rent – payable each 1 November – was set at a single Maltese falcon (a Mediterranean peregrine falcon). Payment continued to be made each year right up until the Order of St John was expelled from Malta in 1798.

Depictions of the seventh-century St Bavo emphasise that he came from a wealthy aristocratic family by showing him in armour with a falcon perched on his hand, although we usually see a monastery in the distance to emphasise that he rejected the vanity of earthly pleasures in favour of service to God. Bavo has become the patron saint of falconry.

St Bavo with a Sword and Falcon Geertgen tot Sint Jans Netherlandish Late 15th century

Falconry is also known as hawking, which leads to
some confusion since hawks are actually of the same
family as eagles (*accipitridae*), to which falcons are
only very distantly related. Unlike eagles, falcons kill
not with their feet and claws but with their beaks.
Many other birds of prey (raptors) have been used
for falconry, even golden eagles, buzzards and owls,
although the latter are far less common than they were
in the days of Frederick von Hohenstaufen.
Although there are some sixty or so known species
of falcon, the bird most commonly used for hunting

*Henry, Margrave
of Meissen,
out Falcon Hunting
Miniature from
the Codex
Manesse. Zurich
1300–40*

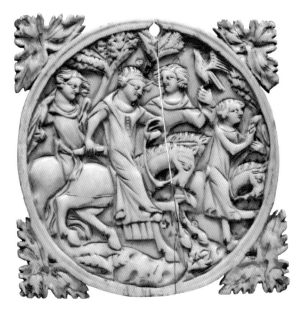

*Departing
for the Hunt
French mirror case
14th century*

is the peregrine falcon, the fastest creature on earth.
When it dives towards its prey it can reach speeds
of up to 320 km an hour, so fast that to enable it
to breathe it has special cones projecting in front of
the nostrils. It is no surprise, therefore, that the falcon
gives its name to high-speed modern technology
such as a rocket launcher used in space exploration.

215

In the very first book of *The Art of Falconry*, Holy Roman Emperor Frederick II declared 'Falconry is an art more noble than other forms of hunting', and such was the perceived nobility of the falcon itself that it was seen as a symbol of the magnanimity and protection of the weak that symbolised a good ruler.

The falcon preys only on large birds, and it would let itself die before it would feed on the young or eat putrid flesh.

Leonardo da Vinci (1452–1519), from *Bestiary*
Tr. Edward MacCurdy (1939)

From the eighteenth century a number of ruling houses introduced orders of the falcon, from the Order of the White Falcon of Saxe-Weimar-Eisenach established in 1732 with the motto *Vigilando ascendimus* (Through vigilance we ascend), to the Icelandic Order of the Falcon established in 1921 and the short-lived Czechoslovak Order of the Falcon founded in 1918 but abolished in 1919.

Kitchen. David Teniers the Younger. Flemish. 1646

It was the development of firearms that largely put an
end to falconry in Western Europe. Then the twentieth
century decimated the falcon population. Not only
did farmers kill them to protect their livestock but
during the Second World War the British government
ordered that all peregrine falcons be destroyed in order
to preserve the carrier pigeons who were so vital in
conveying messages. Today the birds are protected
and falconry is enjoying a revival, not as a common
sport but for displays of the birds' aerial acrobatics.
Hunting with birds remains a vital part of the heritage
of many Central Asian, Arab and Eastern lands,
however. UNESCO has recognised falconry as 'an
intangible cultural heritage' of the Bedouin people
of the Gulf States, one that is 'worthy of protection
and promotion'.

A falcon hovers at the edge of the sky.
Two gulls drift slowly up the river.
Vulnerable while they ride the wind,
they coast and glide with ease.
Dew is heavy on the grass below,
the spider's web is ready.
Heaven's ways include the human:
among a thousand sorrows, I stand alone.

Du Fu (712–70). Tr. anon.

In Japan the first hunting falcons belonged to Emperor Nintoku in the fourth century and *takagari* (falconry) was just as much an aristocratic pastime as in Europe. To own a falcon was a sign of high status and it was only after the Second World War that the imperial house closed down the office responsible for falconry!

Falconer
Kikugawa Eizan
Japanese
woodcut
19th century

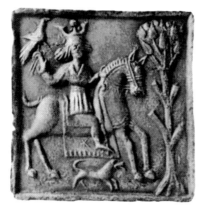

Hunting with birds of prey in Russia dates from at least the ninth century, when it was adopted from the nomadic people of the steppes. Early Russian princes of the ninth to twelfth centuries were passionate about falconry and the pastime is mentioned in one of the earliest Russian epic poems, *The Lay of the Host of Igor* (late twelfth century). The third-century martyr St Tryphon is revered as the patron of birds in Russia, where icons frequently show him holding a falcon, or more particularly a small falcon known as a merlin or pigeon hawk.

In Russian folklore a soldier prince or handsome hero is often described as a falcon and there are tales

Hunter with a Falcon Russian tile 16th century

The Holy Martyr Tryphon with a Falcon Russian icon 17th century

220

of brave youths who could turn themselves into birds to spy the land or hunt. Traditional wedding songs also called the groom a falcon and the bride a swan. In modern times birds of prey are often used to keep away pigeons and crows that foul monuments and squares in cities. Among the soldiers who protect the Kremlin in Moscow, which is a museum as well as the heart of political power, is a small group of falconers whose job is to fly peregrine falcons as well as hawks and eagle owls to scare off small birds and prevent them from spoiling the domes and roofs of the churches and historic buildings.

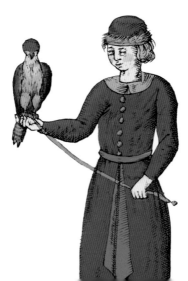

Falconer Illustration from Nikolay Kutepov's book Princely and Royal Hunts in Rus. 1896

Fair Princesse of the spacious air,
That hast vouchsaf'd acquaintance here,
With us are quarter'd below stairs,
That can reach heav'n with nought but pray'rs…

Bright heir to the bird imperial,
From whose avenging penons fall
Thunder and lightning twisted spun!
Brave cousin-german to the Sun!
That didst forsake thy throne and sphere,
To be an humble prisoner here;
And for a perch of her soft hand,
Resign the royal woods' command.

How often would'st thou shoot heaven's ark,
Then mount thy self into a lark;
And after our short faint eyes call,
When now a fly, now nought at all!
Then stoop so swift unto our sense,
As thou wert sent intelligence!

Free beauteous slave, thy happy feet
In silver fetters vervails meet,
And trample on that noble wrist,
The gods have kneeled in vain to have kist…

Richard Lovelace, from *The Falcon*. 1651

In the twenty-first century peregrine falcons have become city inhabitants, nesting on tall buildings and in high chimneys. With a ready food supply in the abundance of feral pigeons, they have adapted well to urban life. By 2018 there were seven pairs nesting in London, one of them spending the non-breeding season on the roof of the Houses of Parliament. In Paris, falcons nested atop Notre Dame Cathedral in the nineteenth century but then disappeared. It was only in 2011 that a pair successfully bred – on top of a central heating vent near the Eiffel Tower.

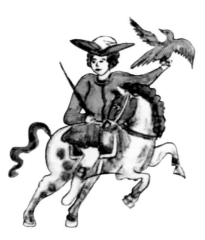

Rider with a Falcon Russian tile 18th century

Nightingale

A match of nightingales. A watch of nightingales

I went to the garden one morning to pick a rose
and suddenly heard a nightingale's song.
Like me, the poor bird had fallen in love with a rose
and in the field, raised a commotion with his cries.
And as I walked through that field and garden
I thought on that rose and nightingale.
The rose befriended beauty, and the nightingale, love.
Neither showed any signs of changing.
As the song of the nightingale entered my heart,
it got to the point where I could stand it no longer.
Many roses bloom in this garden, but
none plucks a rose without the pain of a thorn.

Hafiz (14th century), *The Nightingale*
Tr. Gertrude Lowthian Bell (1897)

Nightingale
on a Flowering
Branch
Yusuf Zaman
Persian
miniature
1696–97

Small and brown and easy to miss amidst the foliage, the nightingale has a voice that makes an enormous impact. At night its song can be heard up to a mile away. That song consists of more than two hundred melodic phrases and inevitably the nightingale has captured the hearts of poets and musicians. If there are relatively few images of this unassuming bird in art, writers have been inspired since Antiquity to praise its virtuoso singing. Greek writers Aristophanes (fifth century BCE) and Callimachus (third century BCE) identified its trills with the poetic language. For the Roman Virgil (first century BCE), the nightingale's song was Orpheus' lament for his lost love Eurydice. In Eastern poetry, particularly that of Persia, the nightingale symbolises sensuality and arousal, with elements of both joy and bitterness.

Yet, ah that spring should vanish with the rose!
That youth's sweet-scented manuscript should close!
The nightingale that in the branches sang,
Ah, whence, and whither flown again, who knows?

Omar Khayyam. 11th–12th century
Tr. Edward Fitzgerald (1868)

Spring
in the Garden
Persian lacquer
First half
of the 17th century

226

Yon nightingale, whose bursts of thrilling tone,
Pour'd in soft sorrow from her tuneful throat,
Haply her mate or infant brood bemoan,
Filling the fields and skies with pity's note;
Here lingering till the long long night is gone,
Awakes the memory of my cruel lot –
But I my wretched self must wail alone:
Fool, who secure from death an angel thought!
O easy duped, who thus on hope relies!
Who would have deem'd the darkness, which appears,
From orbs more brilliant than the sun should rise?
Now know I, made by sad experience wise,
That Fate would teach me by a life of tears,
On wings how fleeting fast all earthly rapture flies!

Petrarch, Sonnet CCCXI. Mid-14th century
Tr. Francis Wrangham (1817)

Seated on Elysian lawns
Brows'd by none but Dian's fawns...
Where the nightingale doth sing
Not a senseless, tranced thing,
But divine melodious truth…

John Keats, from *Ode*
(Bards of Passion and of Mirth). 1820

European poets continued to see the bird (often identified with a heroine of Greek legend, Philomela, who was turned into a nightingale) as the voice of inspiration or poetry. As George Gascoigne wrote in *The Steele Glass* of 1576, 'This worthy bird hath taught my weary Muse, To sing a song …' And in his *Defence of Poetry* Percy Bysshe Shelley declared:

A poet is a nightingale who sits in darkness and sings to cheer its own solitude with sweet sounds; his auditors are as men entranced by the melody of an unseen musician, who feel that they are moved and softened, yet know not whence or why.

The Garden in Spring Abu-l Qasim al-Husayni al-Isfahani Persian lacquer 1901–2

But for others, such as the rural poet John Clare,
the nightingale was the epitome of nature herself.

I love to hear the Nightingale –
She comes where Summer dwells –
Among the brakes and orchis flowers,
And foxglove's freckled bells.

Where mugwort grows like mignonette,
And molehills swarm with ling;
She hides among the greener May,
And sings her love to Spring.

I hear her in the Forest Beach,
When beautiful and new;
Where cow-boys hunt the glossy leaf,
Where falls the honey-dew.

Where brambles keep the waters cool
For half the Summer long;
The maiden sets her pitcher down,
And stops to hear the song.

John Clare (1793–1864),
To the Nightingale

Decoration in
the Raphael
Loggia
in the Hermitage
1778–88

German Romantic poets of the early
nineteenth century identified
the nightingale with lost or
unrequited love. Poems by Johann
Wolfgang von Goethe and Heinrich
Heine inspired songs by composers such
as Mendelssohn and Brahms.

And life is but a sultry day.
It darkens, and I slumber;
I am weary of the light.
Over my bed a strange tree gleams,
And there a nightingale is loud;
She sings of love, love only ...
I hear it in my dreams.

Heinrich Heine,
from *The Home-coming.* 1827
Tr. Louis Untermeyer (1916)

Decoration in the Raphael Loggia
in the Hermitage. 1778–88

232

In the twentieth century, a song about a nightingale written in 1939, before the outbreak of the Second World War, was to catch on almost by chance. Recorded by the British Force's sweetheart Vera Lynn in June 1940, it might have been just another love song, in which the voice of the nightingale was a metaphor for an outpouring of love and joy. But from September that year London was subjected to a policy of systematic, repeated bombing. As the bombs fell and London burned, people kept their spirits up by concentrating on the good things and by dreaming of the magic of love. *A Nightingale Sang in Berkeley Square* became an almost immediate hit.

That certain night, the night we met,
There was magic abroad in the air.
There were angels dining at the Ritz,
And a nightingale sang in Berkeley Square.

I may be right, I may be wrong ,
But I'm perfectly willing to swear
That when you turned and smiled at me,
A nightingale sang in Berkeley Square.

Eric Maschwitz,
from *A Nightingale Sang in Berkeley Square.* 1939

Magpie

A conventicle of magpies. A tittering of magpies

Magpies get a bad press in Europe. They are credited with killing the young of other birds and with stealing shiny objects. Gioachino Rossini's opera *The Thieving Magpie* (1817) tells the tale of mutual accusations that almost lead to tragedy, until the discovery that all the supposed 'thefts' were the work of a magpie. And in the counting rhyme chanted when we see magpies out in the field or garden, 'One for sorrow, two for joy, three for a girl and four for a boy', we all too often recall only the first line …

But in the East the bird has no such associations. Where Europeans see only the black and white of the plumage, the Chinese look further, to the irridescent greens visible when the bird is in flight. The Chinese name for the birds, *xi*, means happiness and according to one legend, on the seventh day of the seventh lunar month magpies form a bridge to allow the lovers Zhinu and Niulang – a weaver girl and a cowherd separated on opposite sides of the Silver River – to be re-united for a brief time. The annual festival marking their meeting, the Qixi ('evening of sevens') Festival, is thus also known as the Magpie Festival.

Magpies on a Flowering Plum Chinese enamel 18th century

235

Away and away I sail in my light boat;
My heart leaps with a great gust of joy.
Through the leafless branches I see the temple in the wood;
Over the dwindling stream the stone bridge towers.
Down the grassy lanes sheep and oxen pass;
In the misty village cranes and magpies cry.

Lu Yu (1125–1209), *Boating in Autumn*
Tr. Arthur Waley (1919)

Catching
Magpies
Chinese woodcut
Late 19th – early
20th century

236

Hugging his lute, the old harper of Chao
Rocks and sways as he touches the five chords.
The loud notes swell and scatter abroad:
'Sa, sa,' like wind blowing the rain.
The soft notes dying almost to nothing:
'Ch'ieh, ch'ieh,' like the voice of ghosts talking.
Now as glad as the magpie's lucky song…

*Magpies on
a Flowering Plum
Chinese woodcut
Late 19th – early
20th century*

Po Chü-I (722–846), *The Harper of Chao*
Tr. Arthur Waley (1918)

For one British soldier, writing in the middle of the
First World War, the 'great and flashing magpie' was
a sign of cheer amidst the horror of the trenches.

The magpies in Picardy
Are more than I can tell.
They flicker down the dusty roads
And cast a magic spell
On the men who march through Picardy,
Through Picardy to hell…

A magpie in Picardy
Told me secret things –
Of the music in white feathers,
And the sunlight that sings
And dances in deep shadows –
He told me with his wings…

He told me that in Picardy,
An age ago or more,
While all his fathers still were eggs,
These dusty highways bore
Brown, singing soldiers marching out
Through Picardy to war.

T. P. Cameron Wilson, from *Magpies in Picardy*, 1916

A fine bird is more than fine feathers…

Seventeenth-century Dutch and Flemish artists loved to illustrate sayings and proverbs in their paintings, particularly through pictures of different birds, representing various virtues and vices. They had a special fondness for 'the magpie tale', a Flemish adaptation of a fable by Aesop (sixth century BCE). Flying over the king's palace one day, the magpie (a jackdaw in Aesop's original) spied some feathers dropped by moulting peacocks. He gathered them up and tied them on to his own tail and proceeded to strut to and fro proudly. But when he joined the peacocks they immediately saw through his disguise and drove him away, screeching and pecking at him. And when the magpie got back to his companions, he was greeted with mockery and jeering at his pretensions. Thus he not only made no new friends but he lost those he had.

Magpie
Yury Vasnetsov
Russian
20th century

A number of languages include the derogatory concept of 'chattering like a magpie', indicating empty-headed and perhaps malicious gossip. In German, 'to tie something to a magpie's tail' (*etwas der Elster auf den Schwanz binden*) means to spread a rumour.

We also call someone a magpie if they collect all sorts of different and unconnected things, even snippets of information. This grew out of that supposed taste for stealing shiny objects but in the end, does it matter whether the legend does not bear scrutiny, and if a 2014 study at Exeter University has demonstrated that magpies do not really collect or even have a particular taste for shiny things? That image of the magpie collector lives on today. For how many museum collections have been formed by someone who might have been described as a magpie, collecting a bit of this and a bit of that? Might we not say that Ferdinand II, Archduke of Austria, who established the collections at Ambras Castle near Innsbruck in the sixteenth century, was a magpie? Or Hans Sloane, the physician whose bequest of 71,000 items laid the foundation for the British Museum in London? Or even Catherine the Great, whose paintings, prints, sculptures, furniture and thousands of cameos and intaglios formed the basis for the Hermitage Museum in St Petersburg?

The Adoration of the Magi Jan Brueghel the Elder Flemish 1598–1600

Duck

A raft of ducks. A paddling of ducks. A plump of ducks

In the myths of many native peoples, from the Buriat and Samoyed of Siberia to indigenous tribes of North American, the duck is an earth diver that can penetrate deep into the earth to create or save the world. Some believed it was a duck that laid the cosmic egg which, according to the legends of places as far apart as Indonesia and Finland, was the source of the universe. In Karelia in northern Russia, on the shore of Lake Onega, archeologists discovered a sacred site dating from the third to second millennia BCE, with stone carvings of a duck, a frog and a tortoise. These are the progenitors of the world. Ducks appear in art of the Ancient world at least as early as the second millennium BCE, painted on walls in a tomb at Beni Hasan in Middle Egypt, or giving form to cosmetic vessels made in Egypt and Assyria. Yet today the duck is something ordinary, splashing happily on a village pond or waddling around a farmyard. Even something funny, since ducks are not particularly elegant when out of the water. We have to try and adjust the way we look at ducks to understand their importance in human history.

Landscape with a Farm Martin Ryckaert Flemish. 1627

243

At the beginning of the Kalevala, the Finnish epic,
it is from shards of the egg of a diving duck that
the Earth is created. Seeking a place to lay her eggs,
the duck alights upon the shoulders of a maiden
tossed in the ocean waters. Seven eggs she lays but
then the maiden moves:

Then the daughter of the Ether,
Now the hapless water-mother,
Raised her shoulders out of water,
Raised her knees above the ocean,
That the duck might build her dwelling,
Build her nesting-place in safety…
Quick the maiden moves her shoulders,
Shakes her members in succession,
Shakes the nest from its foundation,
And the eggs fall into ocean,
Dash in pieces on the bottom
Of the deep and boundless waters.
In the sand they do not perish,
Not the pieces in the ocean;
But transformed, in wondrous beauty
All the fragments come together
Forming pieces two in number,
One the upper, one the lower,
Equal to the one, the other.
From one half the egg, the lower,

Gold Ring with
a Flying Duck
Scythian culture
4th century BCE

244

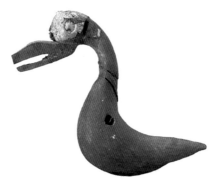

Grows the nether vault of Terra:
From the upper half remaining,
Grows the upper vault of Heaven;
From the white part come the moonbeams,
From the yellow part the sunshine,
From the motley part the starlight,
From the dark part grows the cloudage;
And the days speed onward swiftly,
Quickly do the years fly over,
From the shining of the new sun
From the lighting of the full moon.

Wooden Duck
Ancient Altai
4th century
BCE

Elias Lönnrot, from *The Kalevala*. 1835
Retold by John Martin Crawford (1888)

Ducks have lived with humans for millennia and they appear as amulets, on jewellery and on vessels of all kind in the Ancient world, where they seem to have been associated with fertility and potency.

Penelope, wife of the Ancient Greek hero Odysseus, was the daughter of Icarius and the nymph Periboea. But her father wanted a son and when the girl was born he threw her into the sea. She was saved by ducks, who carried her to the shore and Icarius named her in their honour. The Latin name for the Eurasian wigeon is *anas penelope*.

Ducks appeared on many Greek vases and from the sixth to fourth century BCE the pouring vessel known as an askos (with a spout and top-handle) often took the shape of a duck.

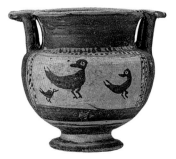

Boy with a Duck. Roman sculpture. 1st century

Gold Earring with Duck Pendant. 3rd century BCE

Three Ducks. Apulian black-figure vase. 4th century BCE

In Asian art pairs of ducks symbolise conjugal happiness, particularly the mandarin duck, whose self-important waddle and flamboyant irridescence were thought to recall the mandarins of the imperial court. When combined with lotuses, ducks represent a wish for happiness.

The sea turns dark –
the voices of the wild ducks
are faintly white.

Matsuo Bashō (1644–94)
Tr. anon.

Pair of Ducks. Chinese nephrite. 18th century

Ducks and Lotuses. Chinese porcelain. Late 17th – early 18th century

On pp. 250–51
Ducks by a Pond. Chinese silk. Late 19th century

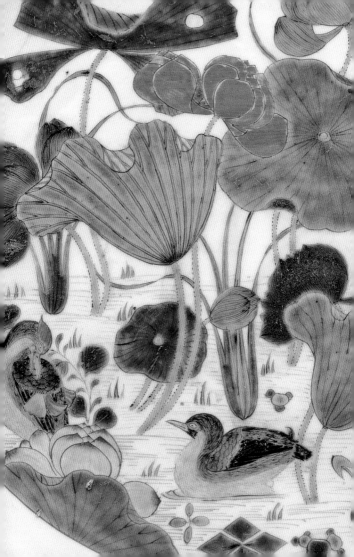

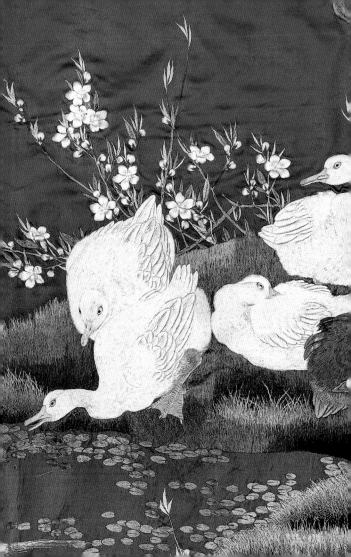

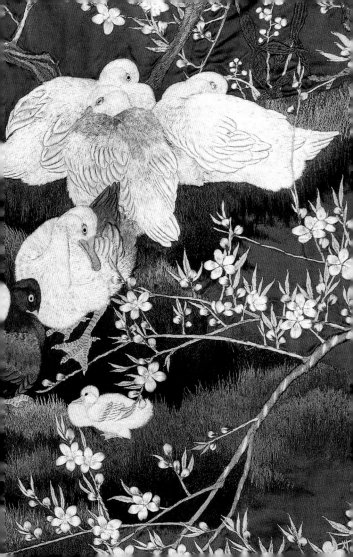

Unlike most domestic fowl, in winter ducks are not taken into the home or barn. They are well able to bear the cold outside, due to the layers of fine down beneath their feathers which insulate against heat loss. Duck down has been used for centuries to fill padded coats and quilts and the old English word for a quilt, eiderdown, takes its name from the eider seaduck of the cold Northern Hemisphere.

Inside the house, ducks might appear in the form of painted vessels, as in the Russian *skopkar*, a form of *kovsh* or drinking ladle. Although some ceremonial 'ladles' could be very big, enough to contain two buckets of mead or beer. A smaller long-handled ladle was used to scoop out the contents.

Wooden Kovsh (Ladle). Russian. 19th century

Ducks appear in the fairytales of many nations. They might, for instance, provide assistance to the heroes in times of danger. In the German tale of Hansel and Gretel, in which the brother and sister get lost in the woods and are captured by a witch, it is a little duck that carries them across the water to safety when they at last manage to escape. Or they might be princes or princesses in disguise. In one Norwegian folk tale, twelve princes are turned into ducks by their jealous stepmother. It seems that they are doomed to remain as birds forever, until their sister comes looking for them. The only way to rescue her brothers is for her to gather enough thistledown to spin into thread from which to make them all shirts, a task of several years, during which time she must remain silent. The princess fulfils her task and at last releases the twelve princes. While in a Russian fairytale a beautiful queen is turned into a white duck by a wicked witch during her husband's absence. The duck lays three eggs but when they hatch the witch kills the ducklings. Seeing their bodies, the duck-queen flies round and round the castle, keening and lamenting. Surprised at the noisy bird, the king emerges to catch it: she flies into his hands and is immediately transformed back into a woman. Reunited, the couple sprinkle magic water on the dead ducklings, who come to life as handsome children, and the wicked witch is put to death.

Said the Duck to the Kangaroo,
'Good gracious! how you hop!
Over the fields and the water too,
As if you never would stop!
My life is a bore in this nasty pond,
And I long to go out in the world beyond!
I wish I could hop like you!'
Said the Duck to the Kangaroo…

Edward Lear,
from *The Duck and the Kangaroo*. 1871

One of the most remarkable ducks ever seen was not
a living being at all but an automaton, the creation
in the 1730s of Jacques de Vaucanson. Known as
the Digesting Duck, it could quack and move and
(apparently) peck at grain and digest it, then defecate.
Although Vaucanson said that the grain was broken
down inside the body, in fact what came out was not
what went in. Displayed in Paris in the winter of 1738,
the duck was accompanied by two android musicians,
and the cost of entry was equal to one week's wages for
an ordinary man. But Vaucanson was not in it for the
money: to him, the whole project was a philosophical
experiment into the nature of life. Sadly, Vaucanson's
duck with its gilded copper feathers was destroyed by
fire in the nineteenth century.

Duck
Russian tile
18th century

Ducks
Dutch tiles
18th century

Ducks have another association with deception, in
that the French word for duck – *canard* – means
a tale intended to deceive, a false rumour. The reason
for the link between the innocent waterfowl and
bamboozlement is unclear, but in the late nineteenth
century *canard* was adopted in English to describe
a hoax and is still used in this way today.

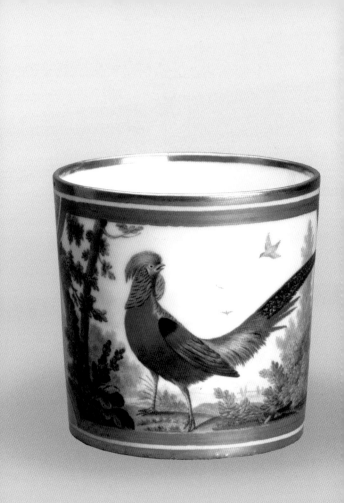

Pheasant

A bouquet of pheasants. A covey of pheasants

Although the pheasant comes from Asia, legend
relates that the birds were taken to Greece by the
Argonauts, who had travelled to Colchis in search
of the Golden Fleece. The bird's name reflects that
supposed origin: the common pheasant is *phasianus
colchicus*, from Colchis, the territory of modern
Georgia, and Phasis, the ancient name of Georgia's
River Rioni. Georgia's historic link with the pheasant
is commemorated in the national arms, which
include a pheasant and a hawk.

Of some 50 pheasant species (43 if we exclude
peafowl and junglefowl), more than half are native
to Tibet and China, the rest coming from the Indian
subcontinent and Indochina. Each seems more
glorious than the last: the green pheasant, blood
pheasant and silver pheasant, the gold pheasant, the
blue-eared pheasant or the bird whose name is as
exotic as its appearance, Temminck's Tragopan. And
despite its name, there is nothing common about
the 'common pheasant'. With its long slender tail and
irridescent colourful feathers, its crest and ear-tufts, the
male struts self-importantly around fields and copses.

*Cup with
a Golden
Pheasant
Sèvres Porcelain
Manufactory
French. 1793*

Introduced to Europe under the Roman Empire, the common pheasant has been part of the landscape so long as to seem like a native. It is the most widespread of the species in Europe and North America, and the most hunted: one estimate in the early twenty-first century suggested that about 36 million birds are shot each year in Britain alone.

See! from the brake the whirring pheasant springs,
And mounts exulting on triumphant wings:
Short is his joy; he feels the fiery wound,
Flutters in blood, and panting beats the ground.
Ah! what avail his glossy, varying dyes,
His purple crest, and scarlet-circled eyes,
The vivid green his shining plumes unfold,
His painted wings, and breast that flames with gold?

Alexander Pope, from *Windsor Forest*. 1704

Despite being so widely hunted, the common pheasant is not threatened in the way so many other kinds of pheasant are: some 50 million birds are specially bred each year just to cater for shooting parties across the world.

Pheasant and Swan. Workshop of Philippe de Lassalle
French. 1770s

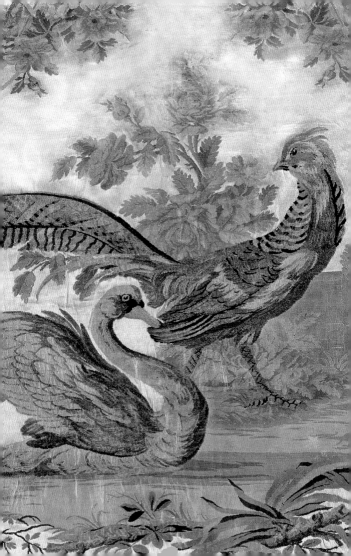

Away the startled pheasant flies,
With lazy movement of his wings.
Borne was my heart's lord from my eyes; –
What pain the separation brings!

The pheasant, though no more in view,
His cry, below, above, forth sends.
Alas! my princely lord, 'tis you –
Your absence, that my bosom rends.

At sun and moon I sit and gaze,
In converse with my troubled heart.
Far, far from me my husband stays!
When will he come to heal its smart?

Ye princely men who with him mate,
Say, mark ye not his virtuous way.
His rule is – covet nought, none hate; –
How can his steps from goodness stray?

Confucius (551–479 BC),
A Wife Deplores the Absence of her Husband
Tr. James Legge *(1876)*

Pheasant. From the album Flowers and Birds
Japanese woodcut. 19th century

*Treading on the tail
of the copper pheasant,
spring's setting sun.*

Yosa Buson (1716–83)
Tr. anon.

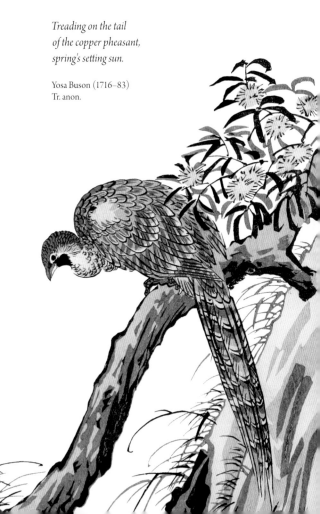

Japan's national bird is the green pheasant, which is found all over the country. Since Japan is particularly vulnerable to earthquakes the green pheasant's sensitivity to earth tremors, which cause it to call out in alarm, is of great importance.

In China, meanwhile, it was the golden and silver pheasants that were revered, their noble mien and proud walk ensuring them a place among the twelve elements of imperial regalia. A golden pheasant was the symbol of high rank. Despite its look of fragility, the golden pheasant is an extremely hardy bird, its natural habitat the mountain forests of western China.

Pheasant. Chinese reverse-glass mirror painting. 1740s–1750s

Pheasant Family. Imperial Porcelain Manufactory
Russian. 19th century

262

Heron

A hedge of herons. A sedge of herons. A siege of herons

The Bennu bird was an Ancient Egyptian deity that personified the soul of the sun god Ra. It features in Egyptian hieroglyphics and paintings, and in appearance seems very like a grey heron. But it is thought that the real inspiration for depictions of the Bennu bird was a large, now extinct, heron that lived on the Arabian Peninsula. The Bennu bird shares many common characteristics – though not its looks – with the phoenix, having been said to be 'self-created' and seen as symbolising rebirth.

Herons come in all sizes, although they have different names: if the largest is the Goliath heron, at over 1.5 m tall, the smallest – including the little bittern, least bittern and dwarf bittern – reach less than 30 cm. But all of them have extremely flexible necks which can retract entirely (for instance during flight) or bend in an elegant S. And the noises they make – croaking and growling – are in stark contrast with their dignified appearance.

For the Greeks a heron was a good omen. In Homer's *Iliad* (eighth century BCE), for instance, Athene sends a heron to Odysseus and Diomedes when they set out

*Amulet,
Symbol
of a Heart, with
a Bennu Heron
Ancient
Egyptian
1st millennium
BCE*

265

on a dangerous night mission. Though they cannot
see the 'long-winged' heron, its call and the 'shrill clang
and whistling wings' give the heroes courage as they
'hail the glad omen', reassured of ultimate success.

*Herons came, with a great bold noise as of opening doors
and shutters, out of the boughs of a plantation which
they frequented at the side of the mead; or, if already on
the spot, hardily maintained their standing in the water
as the pair walked by, watching them by moving their
heads round in a slow, horizontal, passionless wheel,
like the turn of puppets by clockwork.*

Thomas Hardy, from *Tess of the d'Urbervilles.* 1891

Intaglio:
Flying Heron
Dexamenos
Ancient Greek
5th century BCE

Heron
and Snake Jug
Asia Minor
1st century BCE

266

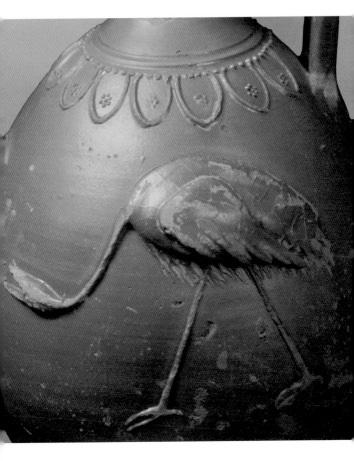

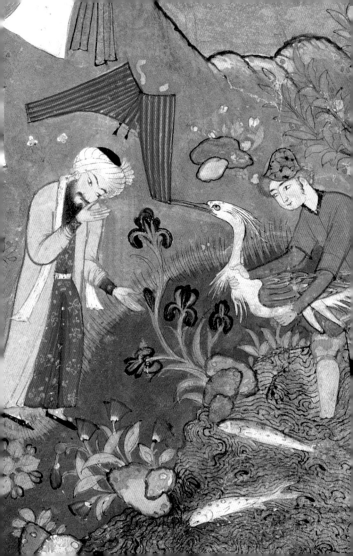

The bird was also thought to be able to forecast rain,
a belief that continued into the medieval period, when
bestiaries described the bird as being frightened
of rain and therefore flying high to avoid storms.
A heron taking flight was thus seen as an indication
of bad weather, but, more importantly, it had a
moralising meaning: this bird, which soars above
the disorder of the world below, is like the human
soul, which must be above all earthly vanities.

In Persian literature there are frequent references to
an aquatic bird of semi-legendary status called the
būtīmār that is generally thought to be a kind of heron.
The name means 'sad owner of waters' and the bird
was said to grieve when water dried up, sometimes
even refraining from drinking itself in order not to
reduce the waters further.

The heron also appears in a didactic Persian tale of the
fifteenth century, Djāmī's *Golden Chain*, in which the
bird tries to fly higher than an eagle, way up above the
clouds, but overreaches itself and tumbles down into
the water (herons, we should note, live by but not in
or on the water). The heron then has to be rescued by
a youth who is at the river washing clothes. The moral
is clear: pride comes before a fall.

Djāmī's Golden Chain. Persian miniature. 1587

269

In European medieval moralising 'emblem books', the heron also makes an appearance, again in connection with birds of prey, although there images of it doing battle in the air are accompanied by the device 'Exitus in dubio est' or 'The result is uncertain'. It was thus used as an allegory for moral conflict, the battle within the human soul between good (the peaceful heron) and bad (the aggressive bird of prey), appearing as such in Renaissance paintings of penitent saints

Bird of Prey Attacking a Heron. Woodcut. 17th century

Vase with a Heron. Painted by Carl Frederik Liisbjerg Danish–Russian. 1892

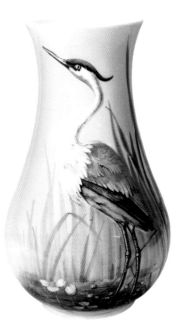

Herons are remarkable for their stillness as they wait
beside the water for their prey to appear, seeming
almost as if in meditation. They have captured
the imagination of artists of both East and West and
inspired the writing of many Japanese poems,
particularly of the three-line haiku form.

*A flash of lightning
and then darkness.
The night cry of a heron.*

Matsuo Bashō (1644–94)
Tr. anon.

*A breeze this evening
and little waves splash
the shins of a blue heron.*

Yosa Buson (1716–83)
Tr. anon.

Herons are central to many Japanese festivals, when
actors put on huge artificial wings and perform the
White Heron Dance. Part of the Gion Matsuri or
festival of the Gion district of Kyoto, former capital
of Japan, it was thought to be a protection against
disease. First held to mark the city's miraculous
recovery from a terrible plague in the ninth century,
in 970 the festival became an annual event.

*Herons at the Ferry Crossing at Sakasai. Hiroshige
Japanese woodcut. 1857*

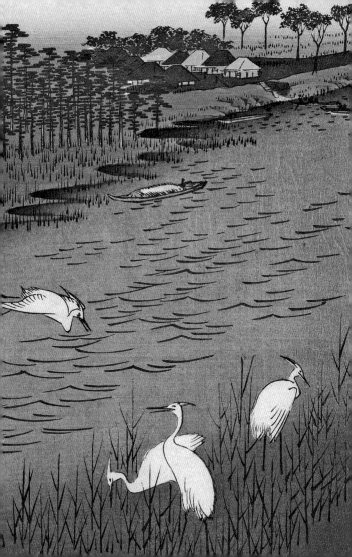

In China the heron brings the energy of the sun into
the house and because it kills snakes it is seen as
a protection against evil forces. Like the crane it
symbolises patience and vigilance, like the stork it is
thought to protect children. In combination with
a tortoise the heron represents a blessing, bringing
long life and happiness, and so there is often an image
of a heron somewhere in any Chinese home, whether
a statue, embroidery or painting.

*Heron
on a Tortoise
Chinese
bronze
18th century*

274

The moon shimmers in green water.
White herons fly through the moonlight.

The young man hears a girl gathering water-chestnuts:
into the night, singing, they paddle home together.

Li Po (701–762)
Tr. Arthur Waley (1918)

*Heron. Silver
table decoration
Miura Sahei
Shigeyuki
Japanese. 1880s*

Goldfinch

A charm of goldfinches. A troubling of goldfinches

Let us look upon the world together,
My goldfinch, heads tilted on one side:
Do you, like me, find winter weather
Prickly as a grain of chaff in the eye?

Tail spread boat-like, black and yellow,
Colours splashed around your beak;
Can you tell, you cocky fellow,
Just what a dandy 'tis you are?

What airy thoughts are in his head:
Black and red, yellow, white;
Looking forward, now looks backwards,
But now he looks not – he's in flight!

Osip Mandelstam, *The Goldfinch*. 1936

Goldfinch
Russian–Italian
mosaic
1848–50

For Russian poet Osip Mandelstam the sparkling colours and bright eyes of the goldfinch symbolised hope and thoughts of escape from arrest and exile. But for centuries those same qualities, and the bird's lovely song, meant that the goldfinch was one of the most popular of all caged birds, kept imprisoned in thousands of homes, wealthy and poor, across Europe. By the end of the nineteenth century, in some areas – particularly in Britain – its very existence was threatened. Today, however, the bird is once again to be heard 'sipping and twittering' and seen in fields and woodland fluttering its 'feathers sleek', then 'off at once, as in a wanton freak', as described by John Keats in 1884 (*I stood tiptoe upon a little hill …*).

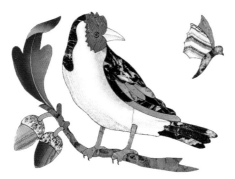

Birds
Italian mosaic
18th century

For all its colourful plumage, with its theatrical scarlet face-mask and yellow flashes in its wings, the bird is very simple in its habits. Its common names include redcap, thistle finch and thistle-tweaker: its scientific name comes from the Latin word for thistle, *carduus*. Thanks to the bird's relatively long beak, it can penetrate deep into the thistle heads to winkle out the little seeds hidden there.

The redcap is a painted bird
and beautiful its feathers are;
In early spring its voice is heard
While searching thistles brown and bare;
It makes a nest of mosses grey
And lines it round with thistle-down;
Five small pale spotted eggs they lay
In places never far from town.

John Clare (1793–1864), *The Redcap*

In 1946 Herbert Friedman devoted a whole book to *The Symbolic Goldfinch: Its History and Significance in European Devotional Art.* For the goldfinch is a very old Christian symbol that has been given a number of interpretations. Partly because of its fearlessness of thistles, it is associated with the crown of thorns pressed down upon Christ's head as part of his sufferings before his crucifixion. Particularly in the Renaissance, artists sometimes showed the small Christ Child holding or feeding a goldfinch, a reference to the Christian doctrine that Christ was born to suffer for the sins of mankind and to die for our sakes. According to popular belief, the red on the goldfinch's head came from the blood that sprang forth on Christ's brow where the thorns pressed into his flesh. As for Osip Mandelstam centuries later, however, the goldfinch also symbolised freedom in captivity and escape from adversity, the human soul capable of taking flight.

Virgin and Child. Leonardo da Vinci. Italian. 1490–91

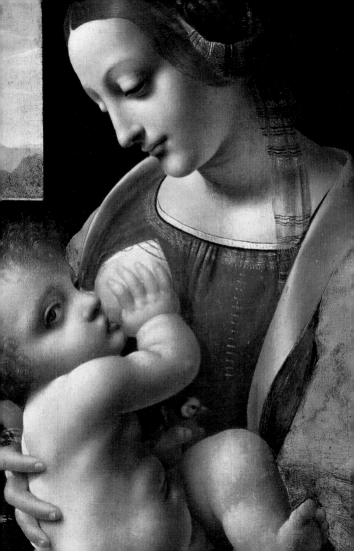

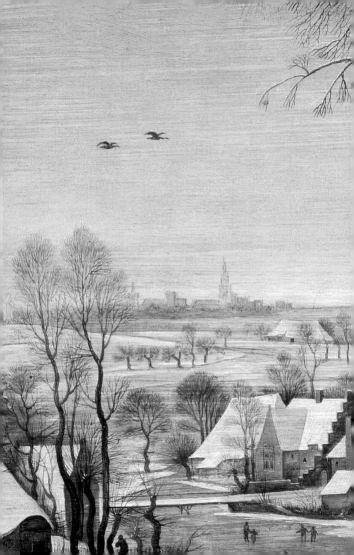

WINGED SOULS

The reason birds can fly and we can't is simply
because they have perfect faith, for to have faith
is to have wings.

J. M. Barrie, from *The Little White Bird*. 1902

Well I've got a house, way up in the sky
Yes, I got a house, way up in the sky
Life may be dreary, but I can still sing
Fly up to heaven, on my soul's wings.

Woody Guthrie (1912–1967),
from *My Soul's Got Wings*

Winter Landscape
Pieter Brueghel
the Younger
Flemish
1615–20

Mankind has dreamed of flight for centuries, millennia even, looking up at the birds in the sky and wishing to join them. The traditional beliefs of many peoples involve the soul taking flight to the heavens, either in hope or prayer or after death, when, freed at last from the weight of the earthly body, it turns into a bird. In life, however, the poet can 'fly', soar high, through inspiration and imagination.

I'm wont, as nature's idle lover,
To stand and watch, lost to the world,
The swallows swiftly darting over
The darkling surface of the pond.

Here's one! It streaks so low and quickly
I have to hold my breath for fear
The alien element might grip it
And hold it if comes too near!

Again it drops, and with elation
Sweeps up into the sky once more.
Is it not like the inspiration
That moves the mind and makes it soar?

Don't I, of clay though I be made,
An element beyond our ken,
A realm forbidden dare invade
and scoop a drop up with my pen?

Afanasy Fet, *Swallows*. 1884
Tr. Olga Shartse

Hope is the thing with feathers
That perches in the soul,
And sings the tune without the words,
And never stops at all,

And sweetest in the gale is heard;
And sore must be the storm
That could abash the little bird
That kept so many warm.

I've heard it in the chillest land
And on the strangest sea;
Yet, never, in extremity,
It asked a crumb of me.

Emily Dickinson. 1862

The Spit
of Vasilyevsky
Island,
St Petersburg
Ludwig Bohnstedt
Russian. 1847

... The night is fair,
And everywhere
A warm, soft vapour fills the air,
 And distant sounds seem near,
And above, in the light
Of the star-lit night,
Swift birds of passage wing their flight
 Through the dewy atmosphere...
I hear the cry
Of their voices high
Falling dreamily through the sky,
 But their forms I cannot see.
O, say not so!
Those sounds that flow
In murmurs of delight and woe
 Come not from wings of birds.

They are the throngs
Of the poet's songs,
Murmurs of pleasures, and pains, and wrongs,
 The sound of winged words.
This is the cry
Of souls, that high
On toiling, beating pinions, fly…

Henry Wadsworth Longfellow,
Birds of Passage. 1858

*View of Kamenny
Island Palace
Gabriel Ludwig
Lory after
Benjamin Patersson
Russian
tinted engraving
1805*

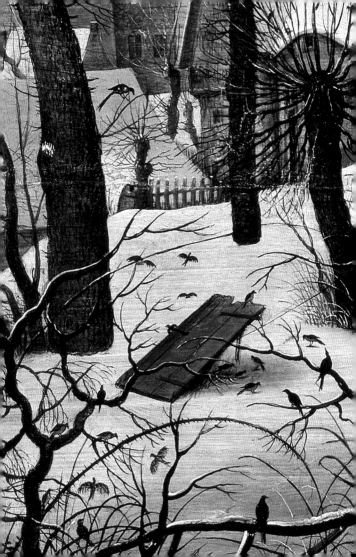

List of illustrations, including details of larger works in this book

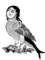
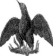
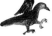

DOVE

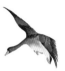

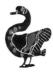

EAGLE

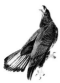

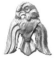

PEAFOWL

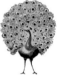

CHICKEN

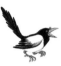

PHEASANT

HERON

GOLDFINCH

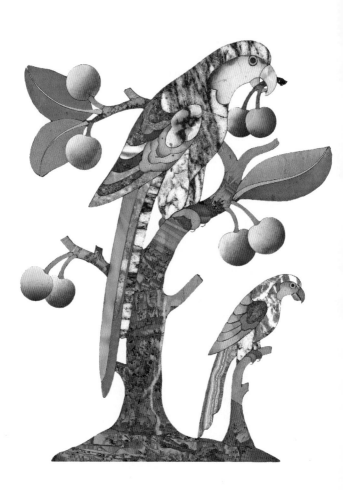

Contents

in alphabetical order

BIRDS *of a feather…*

Design Olga Pen
Photography Darya Bobrova, Pavel Demidov,
Alexander Koksharov, Alexander Lavrentyev,
Yury Molodkovets, Alexey Pakhomov,
Sergey Pokrovsky, Inna Regentova,
Konstantin Sinyavsky, Dmitry Sirotkin,
Svetlana Suetova, Andrey Terebenin,
Vladimir Terebenin, Leonard Heifetz
English text Catherine Phillips
Art director Vladimir Yakovlev
Editor of the English edition Natalia Rogovskaya
Colour correction Igor Bondar
Coordinator Alexandra Naumova

The publisher is most grateful
for assistance in preparation
of this publication to

A. Adamova, A. Bolshakov,
O. Deshpande, A. Ivanov,
T. Lekhovich, M. Menshikova,
S. Nilov, Yu. Piotrovsky,
I. Popova, V. Uspensky

Particular thanks go to

Anna Tjallema, Kirill Kozyrev,
Lev Mochalov, Valery Shulzhik

ISBN 978-5-91208-364-8

Arca Publishers
6–8 Dvortsovaya Square
St Petersburg 191186
Russian Federation
Tel.: +7 812 495 71 42
www.arcapublishers.ru

Printed by PNB Print, Latvia
www.pnbprint.eu